Italy in the Age of Turner

"The Garden of the World"

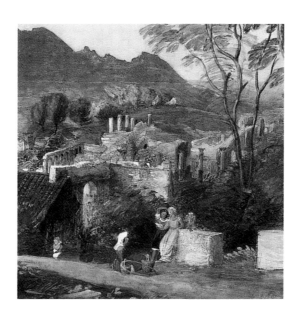

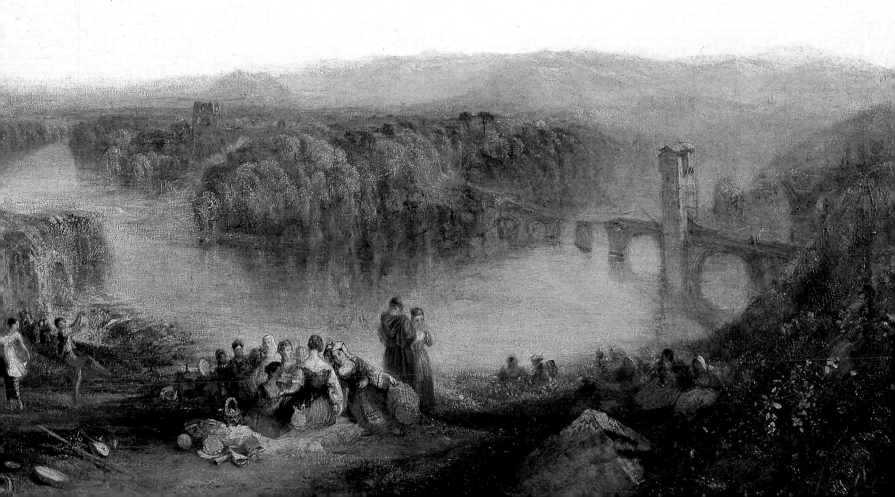

... and now, fair Italy!

Thou art the garden of the world, the home

Of all Art yields, and Nature can decree:

Even in thy desert, what is like to thee?

Thy very weeds are beautiful, thy waste

More rich than other climes' fertility;

Thy wreck a glory, and thy ruin graced

With an immaculate charm which cannot be defaced

Byron, *Childe Harold's Pilgrimage*, IV, xxvi (1818)

Italy in the Age of Turner

"The Garden of the World"

CECILIA POWELL

MERRELL HOLBERTON
PUBLISHERS LONDON

Published on the occasion of the exhibition
'Italy in the Age of Turner'
held at Dulwich Picture Gallery, London
4 March – 24 May 1998

This exhibition has been generously sponsored by
GJW Government Relations Ltd
and
Maritime Orient and Neareast Agency Ltd

GJW Government Relations Ltd
is an award winner under
The Pairing Scheme
(The National Heritage Arts Sponsorship Scheme)
for its support of Dulwich Picture Gallery's exhibition
'Italy in the Age of Turner'

The Pairing Scheme is a Government Scheme managed by ABSA
(Association for Business Sponsorship of the Arts)

Dulwich Picture Gallery is additionally grateful to the following for their invaluable support:
The Friends of Dulwich Picture Gallery
The Paul Mellon Centre for Studies in British Art
Mrs Olga Polizzi CBE
The Stanley Scott Fund

First published in 1998 by
Merrell Holberton Publishers Ltd
Willcox House, 42 Southwark Street
London SE1 1UN

British Library Cataloguing in Publication Data
Powell, Cecilia
Italy in the Age of Turner : "The Garden of the World"
1. Painting, British – Italy 2. Painting, Modern – 19th
century – Italy 3. Italy – In art
I. Title
759.2'09034

ISBN 1 85894 049 4 (hardback)
ISBN 1 85894 057 5 (paperback)

Designed by Roger Davies
Produced by Merrell Holberton Publishers
Printed and bound in Italy

Front jacket/cover J.M.W. TURNER, *Modern Italy – the pifferari*, 1838, detail (cat. 32)
Back jacket/cover THOMAS UWINS, *The saint manufactory*, 1832 (cat. 31)
Half-title SAMUEL PALMER, *The Street of the Tombs, Pompeii*, 1838, detail (cat. 11)
Frontispiece J.M.W. TURNER, *Childe Harold's Pilgrimage – Italy*, 1832, detail (cat. 50)

Contents

LENDERS 6

FOREWORD 7

The Cradle of Civilization 8

The Pleasure of Ruins 20

Painters of Modern Life 38

The Legacy of Claude 56

The Warm South 68

Pictures from Italy 90

The Artists and Italy 104

LIST OF EXHIBITS 116

SELECT BIBLIOGRAPHY AND
FURTHER READING 118

INDEX 119

Lenders

Agnew's, London

The Visitors of the Ashmolean Museum, Oxford

The British Museum

The Duke of Devonshire and Chatsworth Settlement Trustees

Courtauld Gallery, London (Witt Collection)

Cyfarthfa Castle Museum and Art Gallery

The Syndics of the Fitzwilliam Museum, Cambridge

Glasgow Museums: Art Gallery and Museum, Kelvingrove

Leicester City Museums

The Board of Trustees of the National Museums and Galleries on
Merseyside (Emma Holt Bequest, Sudley House)

The National Museums and Galleries of Wales, Cardiff

Northampton Museums and Art Gallery

City of Nottingham Museums: Castle Museum and Art Gallery

Dr Jan Piggott

Dr Cecilia Powell

University of Manchester (Tabley House Collection)

Tate Gallery, London

The Board of Trustees of the Victoria and Albert Museum, London

Victoria Art Gallery, Bath and North East Somerset Council

Foreword

Dulwich Picture Gallery is England's oldest public art gallery. The year of its foundation, 1811, falls in the heart of one of the most important and exciting periods in European history and cultural life. This is the time of the Napoleonic Wars; an age of conflicting principles in the aftermath of the French Revolution; in the arts the age of Romanticism. This is also one of the few great ages of British painting – of Turner, Constable and a wealth of lesser artists. If there is a setting where the art of this period can be understood in context, it is Dulwich Picture Gallery. The permanent collection – for the most part formed at this time – is the tradition of European painting as Turner understood it, a tradition that he and his contemporaries were anxious to respect and join.

Dulwich Picture Gallery has hosted memorable exhibitions devoted to this period of British art – 'Constable a Master Draughtsman' in 1994 and 'Dramatic Art: Theatrical Paintings from the Garrick Club' in 1997. This show fits its venue with a peculiar neatness. Italy has always been a place of pilgrimage for northern artists; the seventeenth and eighteenth centuries are represented in the Gallery's collection by Claude, Poussin, Berchem, Swanevelt, Richard Wilson and many others. The Italian experience of Turner, Samuel Palmer, Eastlake and Edward Lear seen in this exhibition takes up this story in the nineteenth century. Their response is fundamentally different from that of the Grand Tourists of the previous century. The Napoleonic Wars and the enforced isolation they occasioned seem to have given British artists a peculiar excitement at rediscovering Italy. They no longer looked upon it as a museum, but as a place where modern life appeared especially vivid, picturesque and graceful.

We are fortunate to find in Dr Cecilia Powell the perfect scholar to explore this fascinating theme. Cecilia has curated the exhibition, selected the loans and written this catalogue, which makes an excellent complement to her award-winning study *Turner in the South* (1987). She would like to express her thanks here to the following: Michael Kitson for advocating, many years ago, that Turner's Italian work should be studied in conjunction with that of his contemporaries;

David Blayney Brown, Ann Chumbley, Judith Curthoys, Peter Day, Chris Jordan, Simon McKeon, Charles Noble LVO, Bruno Paoli, Sandra Pereira, Jan Piggott, Ursula Seibold-Bultmann, J.A. Theobald and R.G. Thomas for assisting with diverse points of research; Nick Powell for constant help and support of every kind; and Annabel Taylor and Paul Holberton for their heroic work on the catalogue.

We would also like to thank the institutions who have responded so magnificently to our requests for loans, especially the Ashmolean Museum, British Museum, Fitzwilliam Museum, Glasgow City Art Gallery, National Museums and Galleries of Wales, Tate Gallery, and the Victoria and Albert Museum. We are also most grateful to the many private collectors who have agreed to be without paintings, watercolours and books for the duration of the exhibition, but who wish to remain anonymous. We are greatly indebted to Andrew Wyld of Agnew's, Evelyn Joll and various members of staff at Christie's.

We would like to thank members of Dulwich Picture Gallery staff for their wholehearted commitment to this project. Especial mention should be made of Charles Leggatt's fund-raising work, Lucy Till's coordination of every aspect of the exhibition and the installation work undertaken by Allan Campbell, Tom Proctor and Steven Atherton.

Most of all we are indebted to the many most generous sponsors of this exhibition, without whose support it would never have been possible. In particular vital contributions should be singled out from GJW Government Relations Ltd and Maritime Orient and Neareast Agency Ltd. We are especially grateful to Wilf Weeks and Nigel McNair Scott for securing these generous donations and for their tireless commitment to this project. We are also indebted to the Pairing Scheme for coming to our aid for the third year running by matching GJW's donation. The Pairing Scheme is a Government Scheme managed by ABSA (Association for Business Sponsorship of the Arts). This exhibition has also depended upon the lifeline offered by the generosity of Mrs Olga Polizzi CBE, of the Paul Mellon Centre for Studies in British Art, and of the Stanley Scott Fund. As always, a generous contribution from the Friends of Dulwich Picture Gallery has played a crucial part in launching this exhibition.

DESMOND SHAWE-TAYLOR
Director, Dulwich Picture Gallery

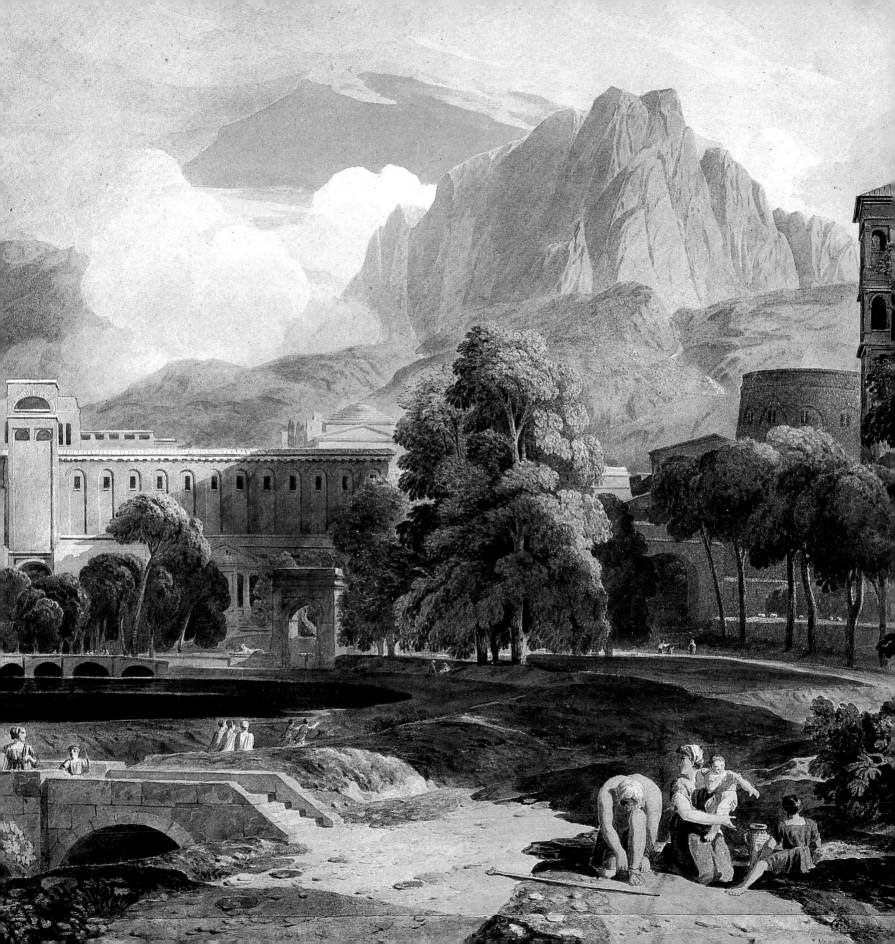

The Cradle of Civilization

Today Britain is a multi-cultural nation and is likely to become even more so in the future. Two hundred years ago the position was very different. British taste and education, the perception of history and literature, art and architecture, were largely dominated by a single, if complex, culture: the civilizations of ancient Greece and Rome, and antiquity reborn, the Italian Renaissance. When Napoleon set his sights on conquering Europe, Italy was a prize in far more than a merely territorial sense. Within three months of his first crossing of the Alps and victories on Italian soil in 1796, he was demanding a hundred of Italy's (indeed the western world's) most celebrated works of art – antique marble statues and vases, Renaissance altarpieces – for his own Musée Napoléon in the Louvre. In April 1797 the convoys of works of art began to leave for Paris where they were eventually paraded through the streets accompanied by ostriches, camels and caged lions in a triumphal procession to rival those of the most decadent of Roman emperors. In May 1797 the last Doge handed the city of Venice over to Napoleon without a struggle and soon many of its treasures also, including the Horses of St Mark's, were on their way to France. In February 1798 French troops marched into Rome and proclaimed it a republic, removing the pope to France as a prisoner.

For the next seventeen years educated Britons were largely cut off from the fountainhead of their civilization; they were deprived of their most significant form of travel, the Grand Tour, with all its opportunities for study, diversion, acquisition and patronage. Around two thousand of them, including Turner, took advantage of the Peace of Amiens (1802) to visit Paris and have a good look at Napoleon's booty in the Louvre, but they were beyond the reach of the cultural magnets of Italy, where some states were now annexed to France, some under French influence, and some the scene of continuing struggles for domination. In these years Britons could savour Italy only at second hand or in their

NOTE:
Biographical information and comments on the
Italian travels of individual artists are given in
The Artists and Italy, pp. 104–115.

Facing page Detail of cat. 2

9

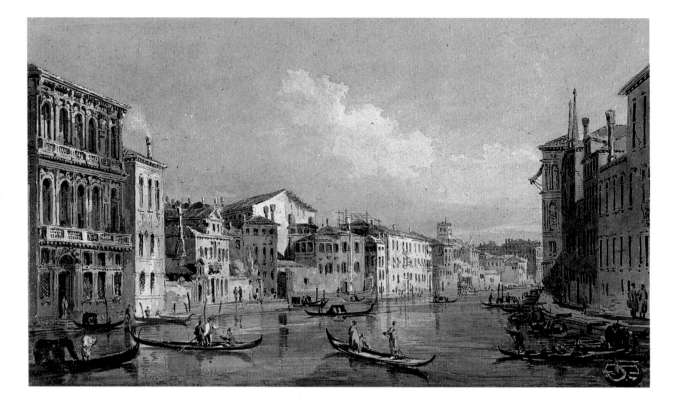

1 THOMAS GIRTIN
The Grand Canal, Venice,
looking east from Palazzo
Flangini to San Marcuola (after
Canaletto), 1797
Watercolour, 24.3 ×
42.4 cm (9³⁄₄ × 15³⁄₄″)
The British Museum

FIG. 1 CANALETTO,
The Bucentaur at the Molo on
Ascension Day, ca. 1755
Oil on canvas, 58.3 ×
101.8 cm (23 × 40¹⁄₈″)
Dulwich Picture Gallery

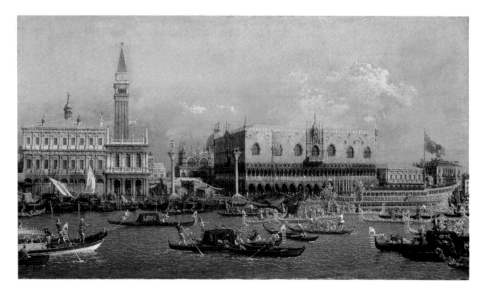

imagination. In the late 1790s Turner and Girtin, both just in their twenties, made watercolour copies after Italian drawings by J.R. Cozens, whose melancholy mood must have seemed highly appropriate at this time. Girtin also drew several copies after the paintings and etchings of Canaletto, an artist especially popular with Grand Tourists (cat. 1). In these watercolours of Venice, painted in the very year its independence was finally extinguished, Canaletto's usual bustle and pageantry (fig. 1) are absent; the air of decay is almost palpable, the buildings crumbling into the canal, the light flickering, the city dying before our eyes.

Other artists retained a more positive image of Italy. In 1808 (the year in which the French reoccupied Rome and Napoleon placed his brother-in-law on the throne of Naples) John Varley saw it as an unattainable paradise. His *Suburbs of an ancient city* (cat. 2) lie in a luxuriant and fertile domain beyond the bleak barrier

2 JOHN VARLEY
Suburbs of an ancient city, 1808
Pencil and watercolour with
stopping-out and sponging-
out, 72.2 × 96.5 cm
(27⁷/₈ × 37″)
Inscr. *J VARLEY 1808*
Tate Gallery, London

of the Alps, a land inhabited by noble and dignified
people who are visibly descended from the models of
Raphael and Michelangelo. Varley's principal building,
with its long lines of round arches and hemispheres, is
evidently inspired by the same antique sources that lay
behind Soane's designs for Dulwich Picture Gallery just
a few years later – and those for some of his London
churches including his first, St Peter's, Walworth. How-
ever, Varley's overall vision of monumental grandeur
was shaped by works such as *A Roman road* (fig. 2), then
highly regarded as a painting by Poussin himself.

After the defeat of Napoleon in 1815, thanks to the
combined strength of Britain and Prussia, Italy became

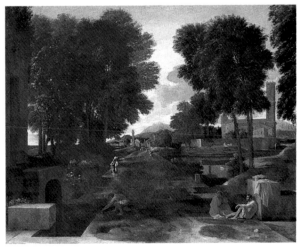

FIG. 2 AFTER
NICOLAS POUSSIN
A Roman road, ca. 1648
Oil on canvas, 79.3 ×
100 cm (31¹/₄ × 39³/₈″)
Dulwich Picture Gallery

11

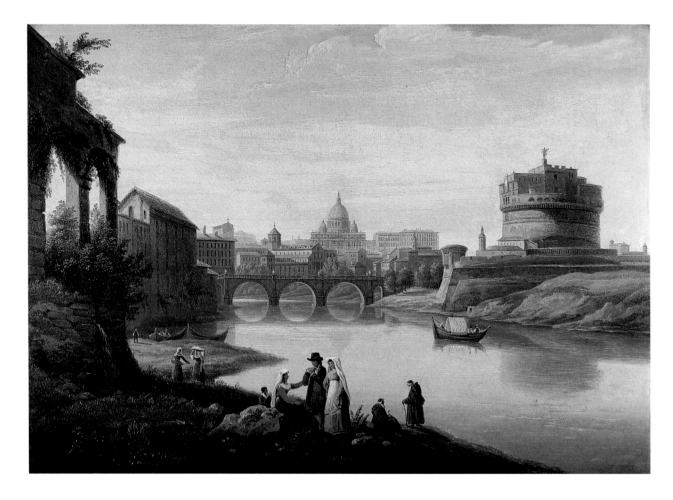

once more the group of states, kingdoms and duchies that it had been for centuries past. It remained so for several decades to come: as Metternich was to remark in 1849, 'Italy' was simply a geographical expression. From 1815, under the terms of the Congress of Vienna, both Lombardy and Venetia were ruled by the Emperor of Austria while other areas of northern and central Italy, such as Tuscany, were governed by minor members of the House of Habsburg. Papal rule was restored in the Papal States, as was that of the Bourbon monarchy in the Kingdom of the Two Sicilies. Britain played a vital role in the restitution of the stolen works of art to their owners in Italy by providing substantial financial aid and working closely with Antonio Canova, Italy's

foremost living sculptor, who superintended the operation. The British themselves returned to Italy in increasing numbers for study, recreation and finally – with the advent of Cook's Tours and the railway – mass tourism.

The first wave of British artists included Sir Thomas Lawrence, who in 1819 painted Pope Pius VII for the portrait series commissioned by the Prince Regent of statesmen and sovereigns involved in the defeat of Napoleon. Both then and later, as President of the Royal Academy, Lawrence encouraged others to visit Italy and study Italian art. This first wave also included important sculptors, ranging from long-term residents like John Gibson to brief visitors like Francis Chantrey. Aristocrats continued to come, among them Canova's

wealthy patron, the 6th Duke of Devonshire, who acquired over twenty cases of works of art on his first visit to Rome in 1819. However, by the mid century British travellers in Italy were not only far more numerous than they had been at any period before the Wars, they also came from a wider social class. The middle classes, unlike Grand Tourists, did not patronize expensive foreign artists but they were nevertheless keen to acquire souvenirs. Thanks to developments in the nature of art publishing (see pp. 90–103), more images of Italy than ever before were produced by and for the British and were more widely disseminated.

British visitors had to travel through many separate states to reach Rome. They also had to forge their way mentally through the many layers of history and countless intermingling strands that make up the cultural fabric of Italy. As the poet Samuel Rogers remarked in 1814, "At Florence we thought only of Modern Italy & of its golden age – As we approach Rome, Ancient Italy rushes on the Imagination. Italy has had two lives! Can it be said of any other Country?"[1] The distinction between the ancient and modern worlds was at its most conspicuous in Rome, which presented formidable problems for the tourist: its antiquities were so widely dispersed that chronological inspection of them was well-nigh impossible, while sight-seeing on a regional basis demanded mental gymnastics of a high order, leaping across the centuries between republican heroes, dissolute emperors and nepotistic popes. Ironically, many of the most exquisite buildings marked the most degenerate epochs of Roman history. Comparisons, contrasts and instances of continuity abounded on all sides. Ancient (that is, classical, pagan) Rome was symbolized above all by the Forum and the Colosseum; modern (that is, Christian) Rome by St Peter's. In William Cowen's version of a perennially popular view of modern Rome, *St Peter's and the Castle and Bridge of Sant' Angelo* (cat. 3), there is at first sight no trace of antiquity, but educated observers like Cowen's patron, the Duke

of Devonshire, would have known that the Castel Sant' Angelo had originally served as the mausoleum of Hadrian; like so many other ancient buildings, it had proved more lasting and adaptable than its creators.

Many other sights and juxtapositions of ancient and modern were equally suggestive, and in 1838 both Turner and then Palmer produced pairs of Italian paintings concerned with this theme. Among his Royal Academy exhibits Turner linked an historical scene from imperial Rome with a contemporary landscape resembling Tivoli (cat. 32 on p. 54). A few months later Palmer (then in Rome and aware of Turner's paintings only by report) produced his own pair. In these the present-day ruins of the Forum stand for ancient Rome while modern Rome is modern in every sense and at every level, though both art and life extend and mimic the past. The scene (fig. 3) abounds in the domes of Christian churches, culminating in St Peter's on the horizon. In the foreground a boisterous procession of the pre-Lent Carnival makes its way through a brand

FIG. 3 SAMUEL PALMER
Modern Rome, 1838
Watercolour and bodycolour on paper, 40.9 × 57.8 cm (15$^{1}/_{2}$ × 22$^{1}/_{2}$")
Birmingham Museums and Art Gallery

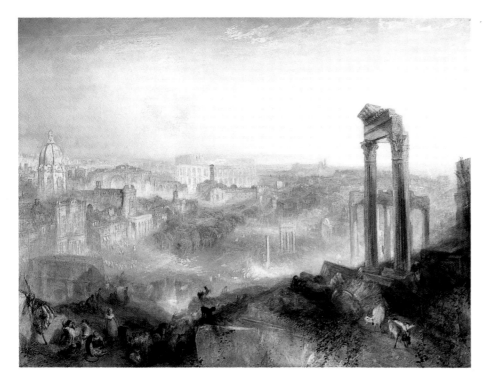

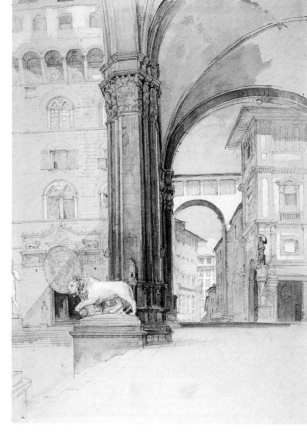

FIG. 4 J.M.W. TURNER
Modern Rome – Campo Vaccino, 1839
Oil on canvas, 90.2 × 122 cm (35^1/$_2$ × 48″)
The Earl of Rosebery, on loan to the National Gallery of Scotland, Edinburgh

4 J.F. LEWIS
Florence: the Palazzo Vecchio and the Uffizi, 1838
Pencil, pen, watercolour and bodycolour, 35.5 × 25.5 cm (14 × 10^1/$_{16}$″)
The Visitors of the Ashmolean Museum, Oxford

new piece of Rome, designed and completed immediately after the French occupation, up the winding road, behind and above the Neoclassical marble groups and fountains of the newly laid-out curves of the Piazza del Popolo to the Pincio, a creation of the early nineteenth century on the site of classical pleasure gardens. The following year Turner exhibited a second pair of scenes, again depicting ancient Rome through a moralizing historical subject from the period of the Roman empire and commenting on modern Rome by showing the Forum in its present state of picturesque decay (fig. 4).

Other cities and regions were hardly less rich in associations. Travellers mused on the lives and fortunes not only of artists but also of writers and thinkers:

Machiavelli, Boccaccio, Galileo, Dante, Tasso, Ariosto, Petrarch (cat. 56 on p. 93). The great figures of the Renaissance came vividly alive in the imagination of the Romantic writers and painters as they reverently visited their houses and tombs and trod in their footsteps: Turner, Callcott and others painted imaginary scenes showing Raphael with his mistress, the Fornarina. Every generation finds that Italy has more levels of meaning and association than the last. In 1789 Turner's early patron Sir Richard Colt Hoare aspired to follow the poet Horace's journey from Rome to Brindisi; his contemporaries were obsessed with the question of precisely where Hannibal had crossed the Alps. At the end of 1814 Rogers was delighted at the accuracy of some lines

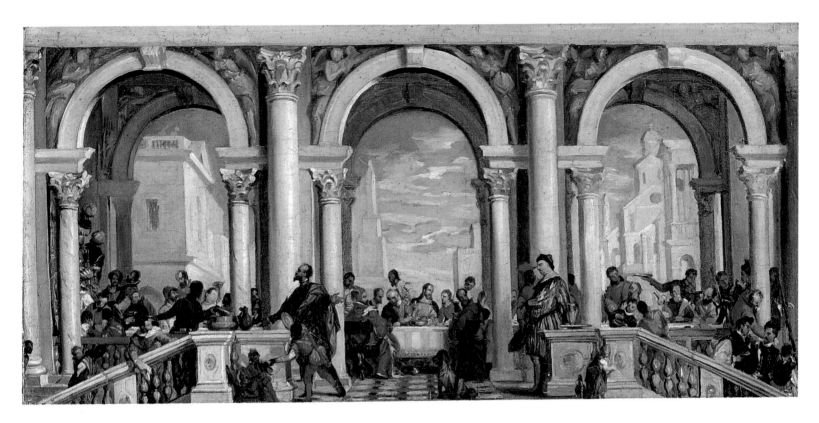

by Milton on Rome, penned nearly two centuries earlier.[2] Just so, we recognize and enjoy the truth to nature of Turner's impressionistic sketches of Rome and Venice; his views have been an inspiration to painters ever since. Few twentieth-century lovers of Florence can look upon the Piazza della Signoria and the Loggia dei Lanzi (cat. 4) without recalling it was here that E.M. Forster's heroine Lucy Honeychurch made the (not uncommon) discovery that there was more to Italy than old paintings and guidebooks.[3] No artist studied 'the true Italy', as Forster calls it, more closely than J.F. Lewis. This exhibition sets out to explore some of the levels at which Turner and his contemporaries experienced Italy. The choice of topics is subjective, as is the allocation of individual exhibits to particular categories. Any kaleidoscope of rich and varied effects can be viewed again and again in different ways; that is part of its beauty.

Most British artists were well prepared for their first taste of Italy since study of the Old Masters had long been central to their education. Intensive copying and analysis (but not, it should be noted, slavish imitation) lay at the heart of the teaching at the Royal Academy Schools and the lectures of its first President, Sir Joshua Reynolds, and students there had access to painted and engraved copies of the most celebrated paintings (Leonardo's *Last Supper*, the works by Raphael and Michelangelo in the Vatican, for example). However, these copies themselves only existed thanks to months, if not years, of hackwork by earlier – and usually minor – artists. In the 1820s Lawrence sent William Bewick to Rome to produce full-size oil replicas of the *Prophets* and *Sibyls* of Michelangelo's Sistine ceiling, a grandiose plan which failed dismally. Engravings inevitably lacked the size, colour, expression, texture and – above all – impact of the originals; some were not even very

5 PENRY WILLIAMS,
The feast in the House of Levi
(after Veronese), *ca.* 1827
Oil on canvas, 24.3 ×
50.5 cm ($9^9/_{16}$ × $19^7/_8''$)
The National Museums and
Galleries of Wales, Cardiff

accurate.[4] On arriving in Italy, most artists spent end-less hours in galleries: analysing, discussing, making themselves and their patrons smaller painted copies (when this was allowed) or private notes and sketches. Paintings like Penry Williams's spirited little copy (cat. 5) of Veronese's huge *Feast in the House of Levi*, now in the Accademia, Venice, receive less attention today than they deserve. They are a salutary reminder that the artists of Turner's era recognized how much they had to learn from the past before they could spread their wings and reach their own potential.

Britain was also rich in copies and plaster casts of the most admired Italian sculptures. Students at the Royal Academy learned to draw from these and had, in fact, to prove their proficiency in drawing from casts before they were allowed to draw from the living nude model. On one of the occasions in the 1830s when Turner was in charge of the Life Class, he arranged for the model to stand next to a cast of the Medici *Venus* and in the same pose – a brilliantly inventive idea which provided a real challenge to the students and was extremely pop-ular. William Etty, who recorded the scene (cat. 6), was no longer a student at this time but a full Academician whose masterly rendering of living flesh juxtaposed to lifeless marble would have been a lesson in itself.

Students at the Royal Academy Schools were a priv-ileged elite. Others enjoyed their first glimpses of Italian art and other Old Masters among the paintings bequeathed in 1811 to Dulwich College, a "little nurs-ery of learning, simple and retired as it stands, just on the verge of the metropolis".[5] The Dulwich Gallery opened to the public in 1814, ten years before the National Gallery. Two South Londoners who particu-larly benefited from the Dulwich collection in their youth were Ruskin and Browning, both of whom became passionate lovers of Italy. Ruskin was just in his twenties and living with his parents on Herne Hill when he wrote the first volume of *Modern Painters* (1843) in defence of Turner. In order to prove Turner's superi-

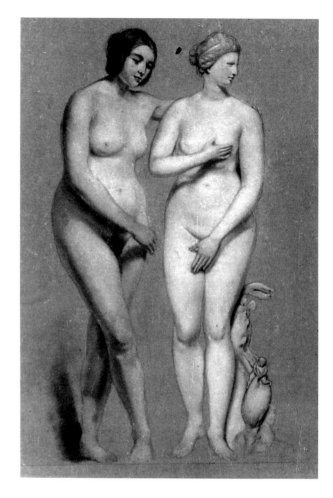

6 WILLIAM ETTY
Female nude posing beside a copy of the Medici Venus at the Royal Academy Life Class, ca. 1835
Black, red and white chalk on light brown paper, 81.3 × 61 cm (32 × 24″)
Courtauld Gallery, London (Witt Collection)

ority over the Old Masters in depicting skies or light or mountain distances, he needed to cite familiar and accessible examples, so he frequently selected the Claudes and Cuyps in Dulwich. Browning, born a couple of miles away in Walworth in 1812, was a fre-quent visitor to the gallery from early boyhood, well below the minimum age then permitted (fourteen). It

was here that he first gazed with fascinated eyes on the Italian painters who spring to life in the poetry of his maturity in the 1850s: Raphael, Andrea del Sarto, Titian, Giorgione, Guido Reni, Guercino, Maratta.[6]

After the Napoleonic Wars, British artists and travellers increasingly extended their gaze beyond the limited canon of High Renaissance artists revered by Reynolds and his generation. Increased travel, a new spirit of enquiry, exhaustion with – and rebellion against – the old ways of study and representation, the desire to get off the beaten track and explore undiscovered parts of Italy: all these led to a diversification of interests and new and fruitful paths. In Florence in 1819 the Irish poet Thomas Moore found "nothing very remarkable" in Santa Maria Novella except a vase by Michelangelo,[7] but within less than a decade the early painters of Tuscany and Umbria were starting to receive close attention and deep appreciation. No longer were they regarded as (at worst) bizarre curiosities and 'interesting specimens' in the history of art or (at best) painters whom Raphael must have looked at and 'improved on'. In the late 1820s the Callcotts made a careful study of the frescos at both Assisi and Padua, Maria Callcott publishing a book on the Arena Chapel in 1835. By 1845, after earnest solitary studies of his own in Italy, Ruskin was certain that Giotto and Orcagna were equal in stature to Michelangelo, hailing the trio as the "three great piers of an artistical Ponte della Trinita, which everybody else has been walking over ever since".[8]

By the time of Turner's death in December 1851, the trend was well under way. British readers could not only enjoy Ruskin's interpretations of the spiritual qualities of the early Italian painters in the second volume of *Modern Painters* (1846) and his equally personal statements of the architectural principles of the period in *The Seven Lamps of Architecture* (1849) and the first volume of *The Stones of Venice* (1851). They could also peruse works on early Italian painting of a more rigorously art historical nature by the Revd J.T. James, Mrs

Anna Jameson and others (some translated from the German). They could buy recent English translations of the classic texts on the subject, Cennini's *Treatise on Painting* and Vasari's *Lives of the Artists*. They could acquire the first prints published by the Arundel Society for Promoting the Knowledge of Art: outlines after frescos by Fra Angelico, soon to be followed by ones after Giotto. They could study the first Early Renaissance works – by Perugino and Lorenzo Monaco – to enter the collection of the National Gallery. Perhaps most importantly of all, they were assisted in their travels as far south as the Val d'Arno by Murray's *Handbook for Travellers in Northern Italy*, first published in 1842. Thanks to the recommendations of its original, anonymous, editor, Francis Palgrave (instantly improved by furious corrections from Ruskin), Britons were diverted from famous galleries in great cities to obscure churches in remote hilltowns and from grandiloquent oil paintings to the directness and sincerity of frescos.[9]

The history of the revolutionary young Pre-Raphaelite Brotherhood, which began in London in 1848, lies beyond the scope of the present work, as does the complex later career of Ruskin. Both, however, benefited directly or indirectly from the life and work of Joseph Severn (cat. 7): in 1820–21 the companion in Rome of the dying poet Keats whose narrative evocations of the medieval world the Pre-Raphaelites loved to illustrate; in 1840–41 the wise painter whose kindly welcome in Rome to a physically and mentally exhausted student Ruskin always remembered with affection. With its intricate mouldings, soaring Gothic vaults, Cimabue frescos, stained glass and superbly carved choirstalls, Severn's view of the apse and north transept in the Upper Church of San Francesco at Assisi encapsulates many of the newly discovered beauties of early Italian art that were so powerful an influence in Victorian Britain. Sadly, it also embodies the fragility of Italy of which many nineteenth-century Britons were aware; as this book is being written, the glories of Assisi

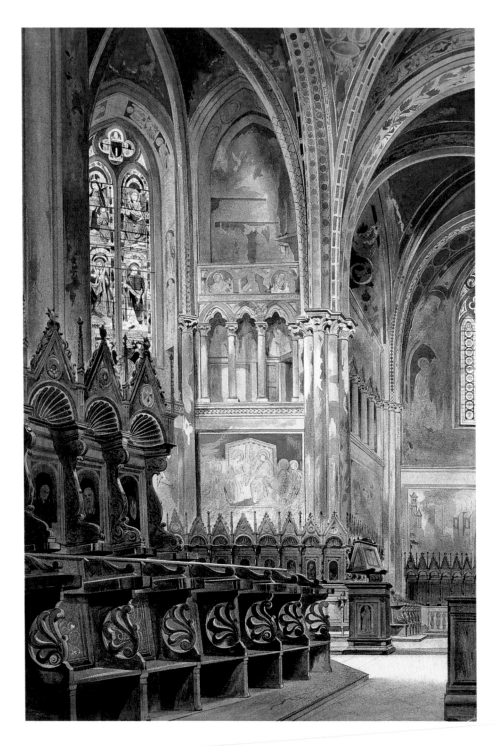

7 JOSEPH SEVERN, *The Upper Church of San Francesco, Assisi, ca. 1820–30*
Pen and brown ink and watercolour, 51 × 34.5 cm (20¹/₁₆ × 13⁹/₁₆″), Victoria Art Gallery, Bath and
North East Somerset Council

are shrouded in dust and rubble, the aftermath of a succession of earthquakes, and some are lost for ever.

The new and broader vision of Italy had its roots in some of the aesthetic tastes and ideas of the late eighteenth century and it was not confined to British artists. On the contrary, they benefited considerably from the fact that Italy itself, and particularly Rome, was an academy and meeting point for many nations. As in the seventeenth century when Claude and Poussin and the many Dutch painters of Italian scenes at Dulwich had lived and worked in Rome, there was constant interplay between visiting artists from different countries north of the Alps; foreigners all tended to live in the same small corner of Rome around Trinità dei Monti and the Spanish Steps, sharing news and ideas as well as lodgings and meals. Interest in early Italian painting, medievalism and the revival of the art of fresco lay at the heart of the Nazarene brotherhood, German forerunners of the Pre-Raphaelites, whom the British artists returning to Rome after 1815 found a new and dominant (if sometimes notorious) force in the city. When the architect Charles Barry visited Italy in 1817, he was amazed at the knowledge of another German, Carl Friedrich von Rumohr, who was engaged in making an inventory of early paintings in Florence and could date and attribute works almost at a glance.[10] In the following decades the Callcotts and Eastlake were on close terms with several of the Nazarenes and their associates, both in Italy and in Germany, and it was Eastlake and his wife who translated Kugler's history of Italian painting into English in the 1840s and later. The new taste was encouraged in Britain by the Prince Consort, German by birth and typically German in his love of linear art and precise drawing.

Meanwhile the French, too, left their mark on British attitudes; though recently defeated on the battlefield of Waterloo, their cultural eminence was undeniable and provided challenges of its own. The traditional French practice of painting studies in oils out of doors to

sharpen artists' perception of nature led many Britons to follow their example; the long-established and enviably well equipped French Academy in the Villa Medici in Rome stimulated a group of resident British artists to set up a similar British Academy in the early 1820s; on the wider artistic front, it may well have been the sight of the recently painted harem interior, *Odalisque with slave* by Ingres, then Director at the Villa Medici, that inspired Lewis to leave Rome for the East in 1840.[11]

If British art was undergoing radical changes in these five decades – in attitudes to the study of nature, in the appraisal of the Old Masters and historic styles of architecture and sculpture – Italy itself was changing even more fundamentally, eventually becoming a 'united kingdom' under Victor Emmanuel II in 1871. Earlier in the century visiting artists recognized the dangers of mentioning politics and religion in their correspondence, the risk of being fined for having books in their luggage or having them confiscated by the officials at one of the endless customs posts through which they passed, the even more dreadful risk of their precious harvest of sketches and paintings being seized on their journey home. The treasure-trove of artists' letters and recollections from Italy in this period reveals a land abounding in paradoxes, a cradle of civilization in which examples of uncivilized behaviour, both ancient and modern, could be remembered or witnessed at every step of the way. "Mourn not for Venice", wrote Thomas Moore in 1819, "she deserves it all":[12]

Vanished are all her pomps, 'tis true,
But mourn them not – for vanished, too ...
Are all the outrage, falsehood, fraud,
 The chains, the rapine, and the blood,
That filled each spot at home, abroad,
 Where the Republic's standard stood.

Italy's stupendous ruins inspired both aesthetic pleasure and intellectual pain; her picturesque inhabitants had dubious morals and strange customs; her idyllic landscape bristled with hidden dangers; her fabled climate could kill as well as cure. No wonder Ruskin had to write reassuringly to his father every day, or Palmer to his newly acquired parents-in-law, the Linnells, almost as often, or Lear and Uwins to their elder siblings. Byron's incomparable 'garden of the world' was – like so many gardens – a place not only of repose but also of peril.

NOTES

1 Hale 1956, p. 206.
2 *Ibid.*, p. 216.
3 *A Room with a View*, London 1908, chapter 4.
4 See S. Lambert, *The Image Multiplied*, New York 1987, especially chapter 7.
5 William Hazlitt, 'The Dulwich Gallery', *The London Magazine*, January 1823.
6 Later scholarship has, however, modified the attributions of some of the works seen by Browning.
7 *Memoirs, Journals, and Correspondence of Thomas Moore*, London 1853, III, p. 36.
8 Shapiro 1972, p. 92.
9 Hale 1954, chapter 5.
10 *Personal and Historical Extracts from the Travel Diaries (1817–1820) of Sir Charles Barry (1795–1860)*, privately published 1986, p. 32.
11 M. Lewis, *John Frederick Lewis, R.A., 1805–1876*, Leigh-on-Sea 1978, p. 18, following the suggestion of Richard Green.
12 From *Rhymes on the Road*, 1819.

The Pleasure
of Ruins

Ruins were central to everyone's interest in Italy. The tower of the Capitol – seen rising above the Forum in cats. 8 and 9 – provided the perfect place for travellers to get their bearings and many, like Thomas Moore in 1819, climbed it on their first or second day in Rome. They marvelled at the celebrated sights to the south and east – the Forum, the Colosseum, the three triumphal arches, and a host of other ruins as far as the eye could see. On closer inspection, they were staggered by the quantity and the quality of what there was to study, by the incredible size of the fallen fragments compared to the scale of modern buildings, and by the sheer variety of styles and characters. To the north and west of the Capitol stretched the structures of Christian Rome, but even here there were constant reminders of pagan antiquity. The Pantheon had escaped destruction through its transformation into a Catholic church; but the splendid marble façades of churches, palaces and houses bore witness to the wholesale ransacking of the mighty ruins for building materials over a period of many centuries.

The archaeological sites in Italy which are world famous today looked very different in 1819 and most were used for a multiplicity of purposes. Thanks to the accumulated debris of centuries, the discrepancy in ground level between ancient and modern Rome was considerable – sometimes as much as forty feet;[1] standing columns were often half buried, their fallen companions quite invisible. Huge mounds of earth and stones from earlier excavations lay all around the Forum, hindering further progress, while partially extricated monuments like the Arch of Severus appeared to be sitting in vast pits. Tourists thus had the strange experience of partly looking down on triumphal arches rather than gazing up at them. The original function of buildings – indeed, of entire areas – was far from obvious to the untutored eye. For centuries the Forum had been used as grazing for cattle (hence its colloquial name of 'Campo Vaccino') and other agricultural and economic

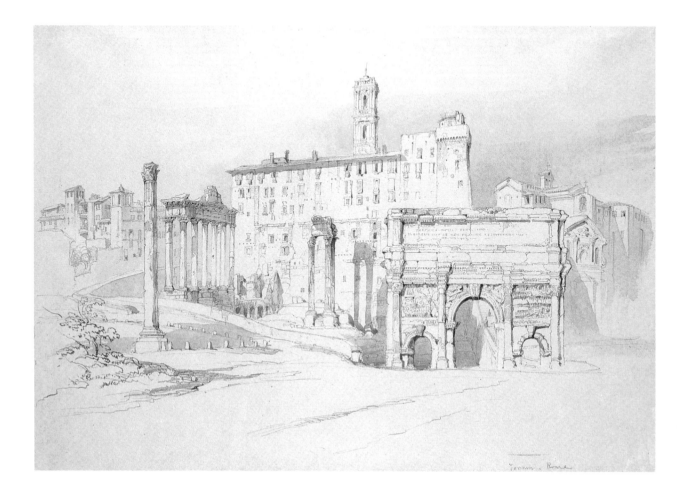

purposes, as can be seen in Claude's painting in the Louvre and its variant in the Dulwich Picture Gallery (fig. 5). Much of the Palatine was a veritable wilderness of scrub where tourists might suddenly come across foxes, but its rich soil was also used for growing cabbages and artichokes. The interior of the Colosseum contained a crucifix and a series of aedicules with the Stations of the Cross and it was the destination of frequent religious processions, but its crumbling arcades defied all attempts to keep wild flowers and weeds at bay; 261 different plants were recorded there in 1815 and no less than 420 in 1855.[2]

One sight that British tourists both expected and enjoyed among the ruins was the process of excava-tion. As in the eighteenth century, there are few true records of this in the art of the period, though figures with spades and wheelbarrows are sometimes introduced to provide an air of verisimilitude. Sentinels, too, are shown, since some of the work was done not by paid labourers but by gangs of criminals in chains, under military guard. The French excavations of 1809–14, continued under the administration of Pope Pius VII after his return in May 1814, dramatically extended the amount of ancient Rome that tourists were able to see. Naturally, few Britons visited Rome under the French occupation, but for those who came after 1814 the buildings of ancient Rome were both more intelligible and far more exciting. British visitors and guidebooks were

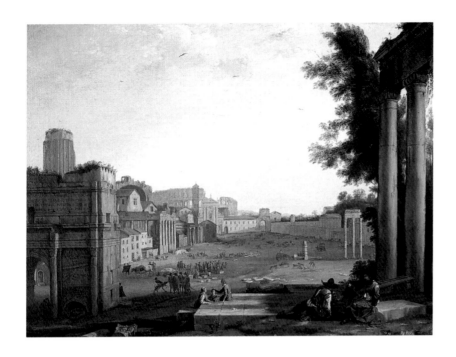

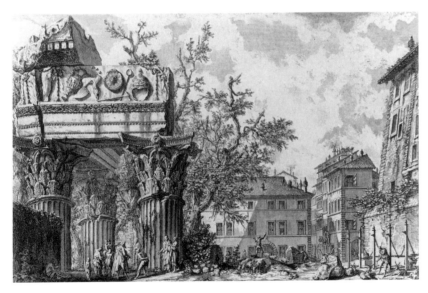

FIG. 5 CIRCLE OF CLAUDE LORRAIN, *The Campo Vaccino, ca.* 1636
Oil on canvas, 78.1 × 106.1 cm (30³/₄ × 41³/₄″), Dulwich Picture Gallery

FIG. 6 GIOVANNI BATTISTA PIRANESI, *View of the Temple of Jupiter Tonans*
(now known as the Temple of Vespasian), 1756
Etching, 39.7 × 59.2 cm (15⁵/₈ × 23⁵/₁₆″), from *Vedute di Roma* (1748–78)

initially loath to give any praise to their recent enemy and said little on this subject. Many must have preferred to view ruins imaginatively, turning their backs on newly achieved knowledge, like Byron. He addressed the Column of Phocas as "Thou nameless column with the buried base!" years after its base had been excavated and its identity discovered, and mused rhetorically over the tomb of Cecilia Metella with a succession of questions:[3]

> But who was she, the lady of the dead,
> Tomb'd in a palace? Was she chaste and fair?
> Worthy a king's, or more – a Roman's bed?
> What race of chiefs and heroes did she bear?
> What daughter of her beauties was the heir?
> How lived, how loved, how died she?

By the mid 1820s, however, the most widely used English guidebook to the Continent, that by Mariana Starke, was giving credit where it was due, declaring:[4] "Though Rome has, in some respects, suffered from her late Rulers, the French, she is, generally speaking, obliged to them; as they removed the earth with which time had buried part of the Coliseum; disencumbered the temple of Vesta from the plaster-walls which destroyed its beauty; excavated the Forum of Trajan, the Baths of Titus, and the lower parts of the Temples of Concord and Jupiter Tonans [compare fig. 6 and cat. 10]; removed from the foundations of the arches of Septimius Severus and Constantine, the earth and rubbish by which they were in some measure concealed, and ridded the Temple of Peace of an immense collection of earth, which entombed nearly one third of its remains."

Another notable development above ground was the demolition, in the early 1820s, of all the miscellaneous structures enveloping the Arch of Titus, so that it, too, could be seen in something of its former splendour. It was restored for Pius VII by the architect Valadier.

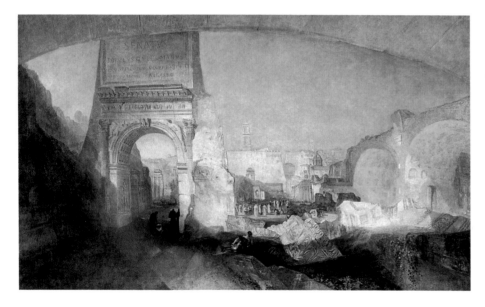

FIG. 7 C.L. EASTLAKE, *View of the Forum of Trajan, Rome,* 1821
Oil on canvas, 38.1 × 90.2 cm (15 × 35½″)
Victoria and Albert Museum, London

FIG. 8 J.M.W. TURNER, *Forum Romanum, for Mr Soane's Museum,* 1826
Oil on canvas, 145.5 × 237.5 cm (57³/₈ × 93″)
Tate Gallery, London

Such was the rate of change that it was impossible for artists to keep up with developments unless they were living in Italy. In 1821 Eastlake, resident in Rome since 1816, was able to depict the newly excavated Forum of Trajan (fig. 7): a place utterly devoid of poetry and associations, with tedious rows of broken columns like the stumps of ugly teeth. The contrast between such a prosaic archaeological site and the mysterious richness of the Piranesi etchings which Byron would have known from his youth make his attitude entirely understandable. In 1819 Turner recorded the Arch of Titus in many detailed sketches and in 1826 he included it as the focal point of *Forum Romanum* (fig. 8), a huge oil painting intended for John Soane. This is not the stripped-down arch resulting from Valadier's attentions, but the complex Piranesian structure, enriched by the accretions of centuries, which Turner had seen in 1819 and still enjoyed in his memory.[5]

Not all the excavation in these years was instigated by the French and the Italians; as in the eighteenth century, the British were closely involved in this field. They took a special interest in the excavations in the centre of the Forum around the mysteriously isolated Column of Phocas (cat. 9) and the three remaining columns of the Temple of Castor and Pollux. This work was financed by the 5th Duke of Devonshire's widow, a key figure in the social and artistic life of Rome in the early nineteenth century; the architect George Basevi described her to Soane in 1818 as "the modern Maecenas of Italy".[6] In 1813 the French had unearthed the inscription which at last revealed the identity of the Column of Phocas, and the Duchess continued excavations in this area which in 1817–18 reached the pyramid of eleven marble steps below its base, standing on the ancient travertine paving of the Forum.[7] Many patriotic Britons gave her the credit for finding the inscription as well.

Basevi and a host of other budding British architects benefited greatly from all these excavations in Rome.

With true ground levels re-established, they could take proper measurements of classical temples and ascertain their real proportions. They climbed ladders (fig. 9), studied mouldings, sketched ornaments (sometimes actual size). They reported to Soane on new discoveries since his own visit to Italy in 1778–79, when he had met Piranesi himself. The architects even had the grace to acknowledge their debt to the French. They felt they were truly at the cutting edge of archaeology, just as Maria Callcott was to do in 1828. She was fortunate enough to be taken by the British sculptor John Gibson to see the excavations near San Giovanni in Laterano, where two Roman sculptures had been unearthed in a vineyard by a gardener just two days previously, and she discussed newly discovered marble statues of antiquity with one of the greatest living masters of that material, the Dane Bertel Thorvaldsen.[8]

Visitors were also thrilled by the ruins of southern Italy. Pompeii, only rediscovered in 1748 and for decades the subject of only desultory activity, was now a far more exciting place to visit than in the late eighteenth century. Thanks to the keen interest of Napoleon's sister Caroline and her husband Joachim Murat, created King of Naples in 1808, excavation there had been generously funded and enthusiastically pursued: some very picturesque parts of the town, including the Street of the Tombs, had been uncovered. Both then and later 'discoveries' were frequently staged for the gratification of the great and the good and also for lesser visitors. In 1821 Anna Jameson saw a house with exceptionally fine

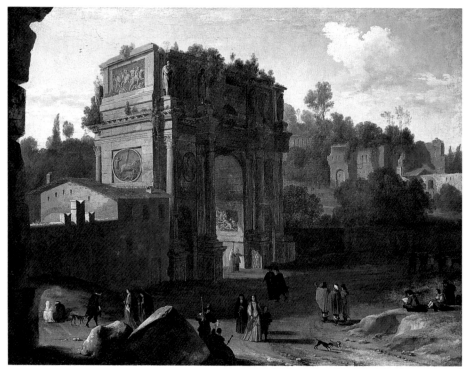

paintings, said to have been discovered less than a fortnight previously, and was shown a fresco by a ragged little *lazzarone* who apparently earned a regular income by unearthing paintings for tourists and reinterring them afterwards.[9] With the return of the Bourbon rulers to Naples, the 1820s saw the discovery of several patrician houses with outstanding paintings, pavements and fountains adorned with mosaics: these included the House of the Tragic Poet with its celebrated mosaic image of the barking dog and the inscription *CAVE CANEM*.[10]

Both tourists and artists needed good viewpoints to enjoy ruins at their most spectacular and in Rome this was surprisingly difficult. The popular prospect from the tower of the Capitol was extremely tricky to record: Palmer achieved it only through sheer ingenuity,

confessing to his father-in-law – a stern advocate of naturalism – that he had amalgamated the view from the top of the tower with another view taken from a window and a third taken from an alley far beneath, and then finally tidied up the perspective.[11] Many artists sought partial views of the Forum or made studies of individual ruins from the closest possible viewpoint so that the contrast between the haughty empire-builders of the past and the humble loiterers of the present could be most strikingly displayed (fig. 10). Swanevelt and many others had done this previously (fig. 11), for the theme is an eternal one. The depiction of just one structure was, however, easier said than done; many of the ruins were hemmed in or overshadowed by later buildings which distracted the eye and reduced the very

thing which tourist souvenirs aimed to recall, the grandeur of antiquity. Prout made a virtue of necessity. In working up his sketches into his many views of the Forum and other historic corners of Rome, he adjusted and manipulated its famous ruins like a stage manager with his scenery: he contrived an overlap here, an interval there, and always with grand dramatic effect. In this way, Rome became far more comfortable for the armchair traveller than for those in the city itself, who must often have felt, with Rogers and Hazlitt, that the ruins of Rome should ideally be in a desert, like those at Baalbec and Palmyra. Sited thus, they would still attract pilgrims but could be properly admired, untainted by

baser matter.[12] It was precisely such majestic isolation which inspired a steady stream of travellers to make the irksome and dangerous journey south to the three lonely temples of Paestum (cat. 61 on p. 96). Standing a few miles beyond Salerno on a plain bounded by mountains and sea, these vast and miraculously preserved vestiges of antiquity aroused overwhelming feelings of solemnity and awe unequalled by any other site in Italy.

The warm colour and crumbling texture of the Paestum ruins had been wondrously replicated in the small cork models of Greek and Roman antiquities manufactured in the eighteenth century for the Grand

11 SAMUEL PALMER
*The Street of the Tombs,
Pompeii*, 1838
Pencil, pen and ink,
watercolour and
bodycolour, 33 × 41.2 cm
(13 × 16¼")
Private collection

Tourist market and much collected by the English (Soane's collection can still be admired today in his house in Lincoln's Inn Fields, London).[13] In the nineteenth century no artist captured the texture of decay better than Prout, whose restless broken lines subtly reveal the vulnerability of his subjects, however monumental they may seem. His Roman scenes, such as *The Temples of Saturn and of Vespasian* (cat. 10), evoke the flakiness of stonework, the chipped fluting of marble columns, the crumbling curves of reliefs and the blunt edges of worn acanthus mouldings so vividly that we

can almost feel them. His Venetian scenes are equally notable for their peeling stucco, rotten woodwork and fading façades (cat. 51 on p. 85). Other artists sought exactitude and a record of static grandeur rather than atmosphere and feeling. In the 1830s and 1840s T.H. Cromek recorded the same scenes as Prout but very differently – with an objective, almost photographic realism (fig. 12). Both styles attracted many patrons.

Things did not go so well for a sensitive artist just four years Cromek's senior, Palmer. In 1838, desperate to attract interest in his Italian work, he chose his view-

points at Pompeii with care and included as many ancient buildings and monuments as possible, hoping to appeal to an architect (cat. 11). His wife Hannah, who often made sketches by his side, followed his example: her view, which Samuel described as *Pompeii with Vesuvius behind it* (cat. 12), shows most of the north-western quarter of the city that had been excavated so far.[14] Palmer did not succeed in his aim, as alien to his true genius as so many of his other occupations in Italy; architects, as a rule, wanted facts, not poetry.

Tourists, on the other hand, need legends and anec-dotes, associations and history to bring ancient sites to life. While Paestum attracted visitors simply by reason of its miraculous and somewhat mysterious survival,

Pompeii drew them because of a single, extraordinary occurrence, the entire town's sudden destruction in AD 79 in the eruption of Vesuvius witnessed and recorded by Pliny the Elder (see cat. 14). Rome, by con-trast, had been the centre of the western world for so many centuries that it abounded in sights of historical interest and associations, so that well-read travellers were reminded of famous events at almost every step they trod. These they recalled with the pleasures of identification and recognition, conjuring up examples of both the heroism of the Roman Republic and the depravity of the Empire. Nor did recent events go unre-marked: the view that had inspired Gibbon to write his *Decline and Fall of the Roman Empire* at the end of the

13 J.M.W. TURNER

The Claudian Aqueduct and
Temple of Minerva Medica,
1819
Watercolour and
bodycolour on white paper
prepared with a grey wash,
22.9 × 36.9 cm
(9 × 14½″)
Tate Gallery, London

eighteenth century also deserved to be savoured, while there was no one who did not wish to share the experiences of Roman ruins so memorably described by Byron in the second decade of the nineteenth.

The history of Rome, so dramatically visible in her ruins, was a powerful example of the rise and decline of great nations and civilizations. Tourists observed with their own eyes how the mighty were fallen, how lofty columns lay broken in the dust, and exquisite ornaments were trodden underfoot. Like the solitary figure in Turner's elegiac sketch, *The Claudian Aqueduct and Temple of Minerva Medica* (cat. 13), they watched the sun setting over desolation and ruin and they reflected on

the vicissitudes of fortune and the transience of all earthly things. Such thoughts were particularly strong in the years immediately following the defeat of Napoleon, with his ruthless desire to dominate the world like the Roman emperors themselves. Napoleon himself had never entered Rome, but if he had returned victorious from Russia in 1812 he had planned to make a triumphal entry into the city and to be crowned in St Peter's. The images conjured up by such potential scenes, so recently and so narrowly avoided, must have caused a *frisson* of pain and pleasure in many a British heart. But other thoughts arose also. As tourists gazed and pondered, they could not avoid the realisation that,

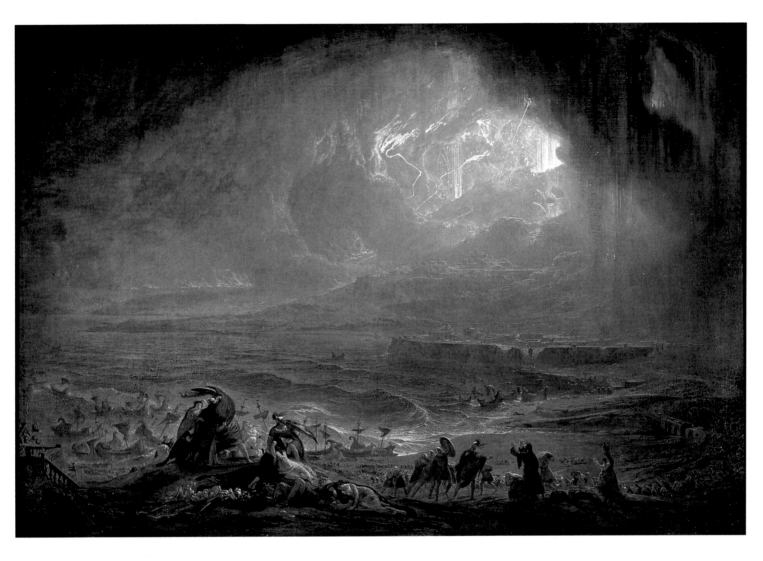

14 JOHN MARTIN, *The destruction of Pompeii and Herculaneum*, 1821–26
Oil on canvas, 83.8 × 121.9 cm (33 × 48″), University of Manchester (Tabley House Collection)

15 EDWARD LEAR,
Porta Maggiore, Rome, 1838
Pencil and watercolour on
paper, 23.5 × 38.4 cm
(9¼ × 15⅛″)
Tate Gallery, London

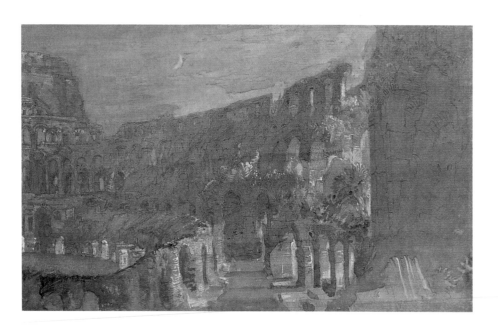

16 J.M.W.TURNER, *The Colosseum by moonlight*, 1819
Pencil, watercolour and bodycolour on white paper prepared
with a grey wash, 22.9 × 36.9 cm (9 × 14½″)
Tate Gallery, London

despite all their culture and the trappings of civilization, the Romans had been barbarians. Lear looked at the gaunt remnants of antiquity in and around Rome with the clear vision of the self-taught artist in a new and strange land and found there a sense of the harsh realities of Roman history: he showed the Porta Maggiore brutally as a stark and primitive wreck (cat. 15). When Dickens reflected in 1846 on all the suffering which the Colosseum had witnessed in its long and bloody history, he expressed his own relief that it was now, at last, "God be thanked: a ruin!"[15]

In Rome – and especially in the Colosseum – travellers courting the mood of loneliness and mystery deliberately enhanced it by moonlight visits. Alone or in parties, they sought solitude and silence and they read the relevant affecting passages from Byron's accounts of lonely, tormented (and often nocturnal) wanderers in the very same buildings, in *Childe Harold's Pilgrimage* (cat. 65 on p. 98) and *Manfred*. Dickens, brooding upon what the Colosseum had really stood for in terms of human suffering, postulated that modern visitors were more profoundly moved by it than by any affliction not their own.[16] In Turner's moonlit sketch (cat. 16) the arena is a place of death: the altars resemble tombstones, the shadowy arcades mimic vaults and catacombs, but not a single soul here rests in peace.

By day, the minds of travellers could be occupied very differently. At Pompeii they derived endless fascination from coming face to face with the ordinary everyday lives of the anonymous men, women and children of seventeen centuries ago, whose domestic utensils and personal ornaments were so incredibly similar to their

own. Parts of shops and houses had been preserved exactly as the lava had suddenly engulfed them, their inhabitants caught pathetically unprepared with transactions abandoned and meals half eaten; visitors were at once moved and enchanted by seeing the simple daily life of Pompeii in all its privacy and completeness and felt that this unique experience had taught them more about antiquity than any number of history books about wars and constitutions. The immediacy of the town's life made visitors like H.W. Williams look round for the inhabitants; his sketch of the truncated walls of a house (cat. 17) has a touchingly direct approach, far from the artificiality of his usual depictions of antiquity.

There was also keen interest in the activity of Vesuvius itself, as there had been throughout much of the eighteenth century, especially on the part of the British envoy Sir William Hamilton, a long-term resident in Naples. An excursion to the crater remained an essential part of everyone's visit to the south: in 1819 Turner made the ascent with T.L. Donaldson, one of the young architects who were busy measuring and drawing ancient buildings, while Uwins escorted a veritable stream of visiting artists there during his many years in Naples. The volcano's occasional slight eruptions, such as those in the late 1820s and late 1830s, were an irresistible subject for artists. Equally fascinating now was the process of destruction which, with the excavation of more and more of Pompeii, could be imagined in greater and greater detail. Soon after the publication of Sir William Gell's *Pompeiana: The Topography, Edifices, and Ornaments of Pompeii* (1817–19) John Martin received the commission for his painting *The destruction of Pompeii and Herculaneum* (1821). For this vast canvas, showing the terrified inhabitants gazing, clinging to one another and fleeing for their lives, Martin consulted every source he could, from Pliny down to Gell; he let his imagination loose only on the pyrotechnics of Vesuvius itself. By a curious trick of fate, the painting was destroyed in a very different disaster a century later, the Tate Gallery flood

of 1928. Fortunately for posterity, however, Martin had also executed a smaller version of the same subject in 1822–26 (cat. 14).

Although Martin's painting received only moderate acclaim at the time, there was no doubt about the popularity of its subject. Edward Bulwer Lytton's vivid novel *The Last Days of Pompeii* (1834) – using up-to-the-minute knowledge of domestic life – soon became necessary reading not only for British travellers in Italy but for everyone interested in the past. The Palmers read the novel in Rome in the winter of 1837–38 in preparation for their visit to Pompeii the following summer and it undoubtedly intensified their response. Emotive phrases – 'dead city', 'city of the dead', 'mutilated victim', 'deathly quiet and silence' – spatter their letters like the black specks of hot ash from Vesuvius caught on the open pages of one of Turner's sketchbooks in 1819. For Hannah the most beautiful and interesting part of the town was the Street of the Tombs; she was deeply affected by seeing the cellar where many skeletons had been found of people vainly taking refuge from the lava, together with marks on the wall bearing witness to their death throes.[17]

The destruction of Pompeii seemed peculiarly poignant, since the town had met its end not through the common processes of history visible elsewhere in Italy – the violence of an invading army, the merciless slow erosion of time, the hands of ambitious later patrons and builders – but through a sudden uncontrollable outburst of nature itself. Destroyed and destroyer remained quiet neighbours under the sun, the remains of Pompeii seeming (as Rogers expressed it) like "the bones that strew the ground at the mouth of a Lion's den; who is only sleeping within – & growling in his slumber."[18]

While tourists recreated the life of antiquity in their minds, painters depicted it on canvas and writers recast it in poetry and novels; the earliest British novel set in ancient Rome, *Valerius* by J.G. Lockhart, Sir Walter

Scott's future son-in-law and biographer, appeared in 1821, the same year as the original version of John Martin's painting of Pompeii. British architects, too, played their part in bringing the heritage of Rome to the streets of their own land. But although some great Neoclassical buildings continued to go ahead despite the long years of war – a good example being Soane's Bank of England (1792–1826), with its visible debts to the Arch of Titus in Rome and the Temple of Vesta at Tivoli – many architects were badly in need of commissions. One such talented designer who lacked architectural commissions of his own was Soane's draughtsman Joseph Michael Gandy, who, with his master's encouragement, turned his hand to dramatic and emotionally charged fantasies. These were based on Gandy's own experiences as a student in Rome in the 1790s and display fidelity to the known rules of classical architecture. However, the Piranesian excesses of his *Classical composition* (cat. 18) have a nightmare quality, like an opium-induced reverie of Coleridge or De Quincey, or as if a macabre episode from a Gothick novel had been transplanted to ancient Rome. Another young visitor to Rome whose later work revels in the eery and frightful atmosphere of its fragmented buildings was the future novelist Wilkie Collins. He was only twelve when his father, the painter William Collins, took his family to Italy for a year, and his first novel, *Antonina* (1850), is filled with vividly imagined scenes of darkness and terror below the tottering walls of Rome as Alaric and the Goths prepare to sack it in AD 410.

As one British visitor in the early nineteenth century remarked, "travellers are the greatest thieves in the world", so constant vigilance was needed on the part of the Italians to prevent further spoliation of their ancient ruins by the vandals of modern times.[19] Papal sentinels stood guard in the Colosseum to deter souvenir hunters. Important new finds at Pompeii were swiftly removed to the museum in Naples or else secured behind gratings on site and well watched by custodians. Hannah

18 JOSEPH MICHAEL GANDY
Classical composition: interior of a ruined palace
Watercolour, 37.8 × 30.2 cm (14⅞ × 11⅞")
Victoria and Albert Museum, London

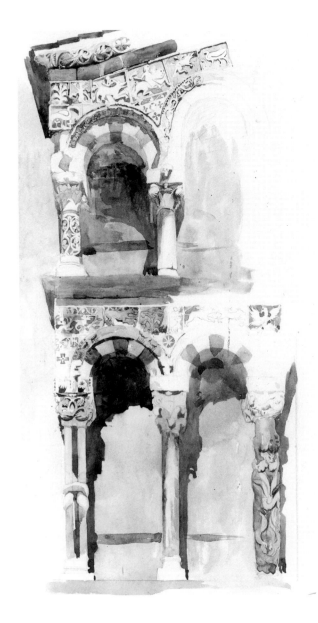

Palmer managed to pick up a few pieces of plaster with traces of coloured paint still on them, but she regretfully told her young brothers it had been "impossible to *steal little antiques*" for them.[20]

It was not only the buildings of Rome and Pompeii that were in danger and not only the tourists who posed a threat to the fabric of Italy. As the twenty-six-year-old Ruskin realised with horror in 1845, the precious heritage of the medieval and early Renaissance periods was perishing, before his very eyes, through the neglect and misuse, apathy and ignorance of the Italians themselves. His daily letters to his father are a catalogue of his sorrow and anger at what he found wherever he went in central and northern Italy: workmen hacking away thirteenth-century frescos in order to erect new memorials in the Campo Santo in Pisa, and whitewashing or plastering over a multitude of other frescos elsewhere; children clambering on bronze doors and standing on the heads of church statues to enjoy better views on a feast day; the exquisite little jewel of Santa Maria della Spina, daintily perched over the Arno, about to be pulled down so that a quay could be widened (cat. 64 on p. 98); the paintings of the world's greatest artists blackened by the smoke of candles or with holes gouged in them to hold oil lamps; a carpet manufactory, with its dust and machinery, installed in the refectory of Santa Croce in Florence; grand medieval arches in Verona being bricked up or stuccoed over; the sublime palaces of Venice with weeds cascading out of the vast rents in their walls.[21] Clearly many of these buildings, too, were on the brink of ruin, mere echoes of the former beauty and civilization of their cities, and the sight of them brought not picturesque pleasure but intense pain. "Tyre was nothing to this", he wrote in Venice to his father; and (in words exactly parallel to those Dickens was to use a year later on the Colosseum, but very differently focussed, reflecting so accurately the concerns and characters of the two men): "I never was so violently affected in all

my life by anything not immediately relating to myself."[22]

These experiences galvanized Ruskin into action, transforming his drawing style from an earnest youthful imitation of Prout (see cat. 8) into an art of documentation based on intensive study and a deep, loving commitment to the buildings themselves (fig. 13). In Rome in 1841, he had no love for its ruins, though he did his best with them on an April morning and in fact produced a brilliantly three-dimensional sketch that positively invites the viewer to explore and to reflect; he himself neither knew nor cared "what the Forum was or ever had been ... or the Arch of Severus, standing without any road underneath, or the ragged block of buildings above, with their tower of the commonest possible eighteenth century type", merely noting that the columns "were on a small scale, and their capitals rudely carved".[23] But his passionate studies of Gothic and Romanesque architecture elsewhere in Italy from 1845 onwards led him to reflect on the many issues surrounding the preservation and conservation of historic buildings, the relative merits of replacing missing parts or leaving imperfect originals, the imitation of ancient techniques by modern, the relocation of structures, the mobilization of support by concerned foreigners, the organization of appeals and subscriptions.[24] By the middle of the century, it was no longer a question of British visitors to Italy simply taking pleasure in all her ruins, but also of keeping ruin itself at bay.

NOTES

1 H. Matthews, *The Diary of an Invalid*, 3rd edn, London 1822, I, p. 77.

2 Hale 1956, pp. 66, 122. The full list of the 261 plants in the Colosseum is reproduced as Appendix II of H.W. Williams, *Travels in Italy, Greece, and the Ionian Islands*, Edinburgh 1820, I.

3 Ridley 1992, pp. xxi–xxiii; C. Springer, *The Marble Wilderness*, Cambridge 1987, pp. 4–14; Byron, *Childe Harold's Pilgrimage*, Canto IV, London 1818, c, cx.

4 M. Starke, *Information and Directions for Travellers on the Continent*, 6th edn, Leghorn 1825, I, pp. 202–03.

5 Soane, however, declined the painting (see Powell 1987, pp. 121–26) and acquired Callcott's *Passage point* (fig. 26 on p. 70) instead.

6 A.T. Bolton (ed.), *The Portrait of Sir John Soane, R.A.*, London 1927, p. 272.

7 Ridley 1992, pp. 123, 124, 298 n.108; Liversidge and Edwards 1996, cat. 14.

8 Bolton, *op. cit.*, pp. 280–82; Lloyd and Brown (edd.) 1981, entries for 15 January and 28 February 1828.

9 [Mrs A. Jameson], *Diary of an Ennuyée*, London 1826 edn, pp. 254–55.

10 W. Gell, *Pompeiana: The Topography, Edifices and Ornaments of Pompeii, the Result of Excavations since 1819*, 1832, chapters VIII, X–XIII.

11 Lister 1974, I, pp. 256–57.

12 Hale 1956, p. 211; Hazlitt 1826, pp. 256–57.

13 Hale 1956, p. 261.

14 Lister 1974, I, p. 153.

15 Dickens 1846, p. 168.

16 *Ibid.*, p. 167.

17 Lister 1974, I, pp.150, 155, 216; Powell 1987, p. 79.

18 Hale 1956, pp. 253–54.

19 Matthews, *op. cit.*, I, pp. 206, 178.

20 Lister 1974, I, p. 151.

21 Shapiro 1972, pp. 51, 61, 62–63, 72, 76, 131, 133, 153, 196.

22 *Ibid.*, pp. 200–01.

23 John Ruskin, *Praeterita*, ed. K. Clark, London 1949, pp. 251, 246–47.

24 On this subject see Michael Wheeler (ed.), *Ruskin and Environment. The Storm-Cloud of the Nineteenth Century*, Manchester and New York 1995, esp. chapter 5

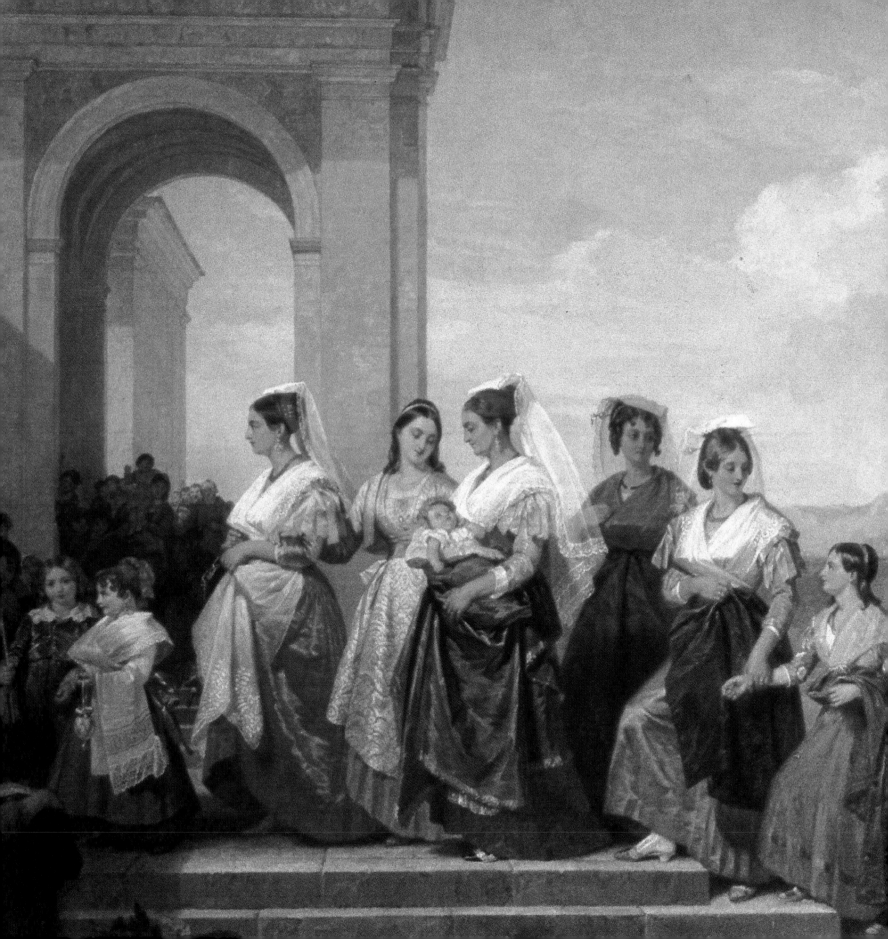

Painters of Modern Life

Artists were lured to Italy by the grandeur of its past but, once there, they were beguiled and distracted by the present. Journeying south past cornfields, orchards and vineyards they were enchanted by the sight of bands of peasants with cheerful healthy countenances, and in both town and country they found that the inhabitants of modern Italy formed naturally picturesque groups. Eastlake, one of the earliest British painters to reside in Italy after the Napoleonic Wars, spent much of his energies on peasants and *contadine* instead of the expected grand historical subjects. However, both he and two Britons who arrived in the 1820s, Uwins and Penry Williams, presented modern Italians as endowed with beauty, grace and stature – worthy successors to their forebears. A decade later Palmer recorded wistfully that Rome would stock him with figures for life (if only he could afford to pay the rate demanded by the models)[1] and Lewis made many fine studies of individual figures in the south before sketching proved too dangerous an occupation and he had to beat a hasty retreat back to Naples. This was all a far cry from the depictions of boorish peasants by seventeenth-century Dutch painters in Rome and from eighteenth-century British practice with its aristocratic and antiquarian emphasis relieved by caricatures of street scenes and coffee-houses.

In the nineteenth century British artists placed the men and women of Italy on the stage conveniently provided by the remnants of antiquity or suggested by the Old Masters, but they saw them as important artistic subjects in their own right, deserving the viewer's full attention. The figures of Eastlake, Lewis and Uwins are at the same time archetypal and convincingly modern. Eastlake's patriarchal goatherd, for instance (cat. 19), rests on the tomb of one of his remote ancestors in a pose that itself goes back to antiquity, but he and his piping companion are arrestingly people of the present, eking out a living in the now desolate wastes of the Campagna. Thirty years before the poet

Facing page Detail of cat. 20

19 CHARLES TURNER
AFTER C.L. EASTLAKE
Italian goatherds, 1825
Mezzotint (after the
painting *Goatherds in the
Campagna of Rome*, 1823),
28.4 × 39.7 cm
(11³/₁₆ × 15⁵/₈″)
The British Museum

Baudelaire coined the phrase 'the painter of modern life' to describe the French illustrator Constantin Guys in 1863, British painters in Italy were already subscribing wholeheartedly to this ideal; they, alas, lacked a major literary figure to call attention to their aims and achievements and had to promote themselves as best they could.

Fortunately, however, there were new classes of patron ready to buy their work. Eastlake's *Italian goatherds* was painted for the distinguished army officer General Sir Moore Disney, who had recently served as a commander in Sicily. A second version of his *Italian family* (cat. 24) was commissioned by the great art collector of Herne Hill, Elhanan Bicknell, who had made a fortune through the Pacific sperm-whale fishing industry. The first (four-foot) version of Lewis's Roman costume piece (cat. 28) was commissioned by William Leaf of Streatham, founder of an important City wholesalers specializing in silks and ribbons, while the final (ten-foot) version of Davis's interior of St Peter's (cat. 29) was painted for the merchant and naval agent John Hinxman. Several Italian paintings by Eastlake, Collins and Uwins were bought by John Sheepshanks, heir to a cloth-manufacturing firm in Leeds, who built up a substantial collection of paintings of modern life by living British artists.[2] Sir Thomas Baring, eldest son of the founder of the merchant bank, acquired modern Italian subjects not only by the already established Collins but

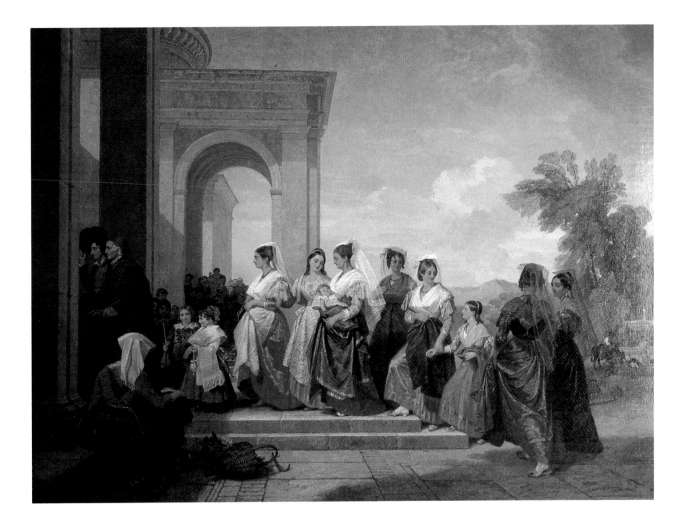

20 PENRY WILLIAMS
The procession to the christening,
a scene at L'Ariccia near Rome,
1832
Oil on canvas, 90 × 121 cm
(35⁷/₁₆ × 47³/₄″)
Cyfarthfa Castle Museum
and Art Gallery

also by the struggling Palmer. Penry Williams sold *The procession to the christening* (cat. 20) to the prosperous iron magnate Josiah John Guest, heir to the Dowlais Ironworks, which was soon to be not just the largest in Wales but the largest in the world. This magnificent scene, clearly influenced by Williams's study of the rich colours, shimmering fabrics and sublime compositions of Titian and Veronese in Venice (see cat. 5), was presented by Guest to his aristocratic bride Lady Charlotte Lindsey, daughter of an ancient though impoverished family, who duly proceeded to bear him no less than ten children.[3]

Traditional regional costumes such as those painted by Williams were immensely popular with visitors. While the family he shows here has the grandeur to match the church they are about to enter – Bernini's Santa Maria dell'Assunzione – life in the valley beneath was characterized by archaic simplicity (see cat. 54 on p. 92). Many herdsmen and other dwellers in the Roman Campagna and southern Italy still wore cowhide, sheepskins and goatskins, just like their ancestors; Lear declared that the shepherds were all dressed in goatskins just like the satyrs of classical mythology and wore their cloaks like the drapery of the ancient Romans.[4] Their high-

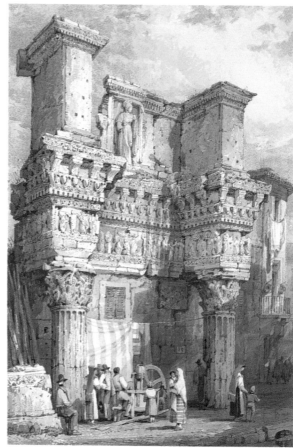

crowned tapering hats recalled those in portraits of Sir Walter Raleigh.[5] However, it took a woman's eye to observe the finer points of detail. Hannah Palmer recorded, "Some of the men and boys wear a loose coat of sheep skin with the wool outside, and trousers a little below the knee, of goat skins which are very beautiful here, long and silky, hats with peacocks feather carelessly put in."[6] When it came to eyeing women's costumes, however, visiting men certainly drank their fill. Hazlitt was struck with their "variety of rich dresses, red, yellow, and green, the high-plaited headdresses ... some in the shape of helmets, with pins stuck in them like skewers, with gold crosses at their bosoms, and large muffs on their hands."[7] Lear enjoyed their "square,

white headdresses – scarlet bodices, and peagreen skirts."[8] Lewis, Prout, Uwins and Williams busily recorded their dazzling colour combinations, brilliantly striped skirts, crisp white linen and bright slippers.

Many of the fascinating sights of modern Italy were, like the regional costumes, no more than the ingredients of everyday life and primitive labour, often evoking neat contrasts between past and present. In Rome all manner of occupations, trades and domestic activities could be observed in every street and alley, outside the countless humble dwellings built into and on to the superb vestiges of the past. The cool and shady marble ruins behind the Portico of Octavia really did serve as a convenient fish market for Rome (cat. 21).

Knife grinders may well have plied their trade beneath the most intricately carved entablatures in the city, such as that above the 'Colonnacce' in the Forum of Nerva (cat. 22). The stately buildings dating from the heyday of Venice's great maritime empire could now be shown surrounded merely by the small craft of traders and fisherfolk which, in stormy weather, were "knocked about like egg-shells, and sometimes crushed as easily" (cat. 23).[9]

Other memorable sights, however, were the product of special festivals or particular seasons: the Carnival, in and around the Corso in Rome between Christmas and Lent; the commemoration of Holy Week and Easter with fireworks over the Tiber and the illumination of Castel Sant'Angelo and St Peter's, right to the very top as Michelangelo himself had intended; the feast of Florence's patron saint, St John the Baptist, in June, with illuminations and fireworks over the Arno; the harvest and the vintage, with their numerous local celebrations and processions (cat. 30); Christmas, heralded in Rome by the arrival of the *pifferari* from the south (cat. 32). Hazlitt, Lear and Hannah Palmer all wrote rapturous accounts of the Roman illuminations, which exceeded every expectation.[10] Lear's delight in the mechanics of the operation in 1838 looks forward to a glorious later invention of his own, the "hollow rounded space ... with holes all round to send the light" belonging to 'the Dong with the Luminous Nose':[11]

"About dusk, men (400) are slung by ropes (!!!) all over the dome & colonnades of St. Peter's – where they

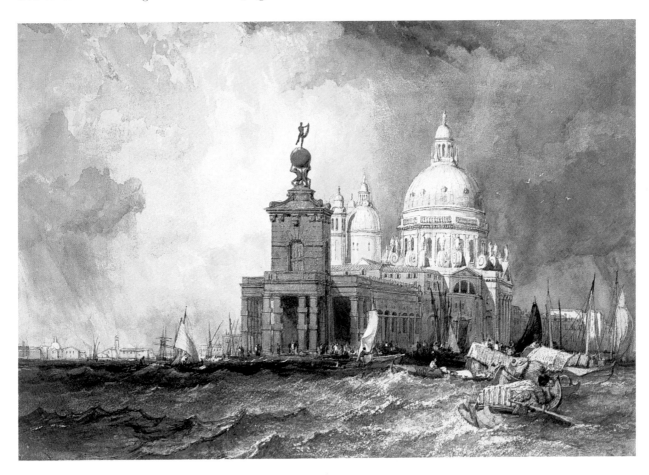

23 CLARKSON
STANFIELD
*The Dogana and the Church of
the Salute, Venice, ca.* 1830–31
Watercolour and
bodycolour, with scratching-
out, 22.2 × 31.8 cm
(8³⁄₄ × 12¹⁄₂″)
The British Museum

put little paper lamps in regular places – till the evening grows darker – every line, column, & window becomes gradually marked by dots of light! It has the exact appearance of a transparent church – with light seen through pricked holes ... about 9 o'clock by an astonishing series of signals – the whole fabric blazes with hundreds of torches; immense iron basins full of oil & shavings are suspended *between* the little lamps, & these all at once burst out into the light!"

In 1845 Ruskin (later an ardent admirer of Lear's nonsense books) viewed the illumination of the cathedral and Palazzo Vecchio in Florence with equal pleasure if less exuberance: "very noble, owing to their using lamps with strong reflectors to throw the light on the walls, which made the marble of the cathedral look perfectly transparent & full of fire."[12]

Sadly, all tourists had to come down to earth again after their most thrilling experiences. Independent travellers could not avoid daily transactions with coachmen and waiters, shopkeepers and custodians of sites and palaces, passport and customs officials at the innumerable borders of all the separate states. These Italians were nearly always regarded as greedy, dishonest, lazy, and helpful only when bribed. Lodgings were often dirty and pestiferous, cramped and evil-smelling. The unfamiliar food was eyed with fear and disgust or occasionally mirth. At Bozzolo, between Cremona and Mantua, Thomas Mills and his wife could not help laughing when served a dinner of four raw turnips, some butter, a piece of boiled beef, a pudding consisting of slices of Bologna sausage, fruit, vegetables and eggs (diary entry opposite cat. 67, illus. p. 99). Life was especially troublesome for women visitors – far more difficult, it must often have seemed, than for the handsome, carefree *contadine* so enthusiastically painted by their husbands and colleagues. The young Hannah Palmer, for instance, was unable to cross Rome from via Gregoriana to the Vatican to carry out her daily task of copying Raphael's frescos while the streets were filled with the throngs and processions of the Carnival. In Naples, it was out of the question for her ever to leave the house on her own to draw the beauties of the bay or the treasures of the museum. At Pompeii she could only make copies of the Roman wall-paintings if her husband was with her the entire time "to protect her from Neapolitan insolence". At the very end of their Italian honeymoon it was quite a relief – for both of them – that she could sit and study in the galleries of Florence without fear of molestation.[13]

Many of the drawbacks of Italian life were, inevitably, seen as the products of society and governments less advanced and enlightened than those in Britain. However, the introduction of the latest modern conveniences into matchless historic cities was not universally welcomed by British visitors. When Ruskin returned to Venice in 1845 after an absence of five years, he was devastated at the changes he found: a railway, complete with scaffolding and workmen, that reduced the divine city to just another London or Liverpool; an "iron station" in place of a church; "omnibus gondolas" for the tourists; gas lamps "in grand new iron posts of the last Birmingham fashion" not only along the tiny canals but even on the Grand Canal itself, with a specially grand lamp-post, "with more flourishes than usual", just by the Bridge of Sighs; the intricate little bridges over narrow canals straightened to carry gas-pipes and fitted with monotonous patent-iron railings.[14] Everywhere he looked he found the nineteenth century had arrived in all its prosaic ugliness. In Ruskin's day, as in our own, for Britons abroad to have the benefits of comfort, speed and safety, there was a very steep price to be paid.

While Ruskin was distraught to find that Venice and other towns were not simply museums where time stood still, in a land which existed solely for aesthetic pleasure and education, the countryside provided visitors with its own notorious problems. Brigandage was still rife in the papal territories and the south, as it had been for

centuries past, despite harsh measures adopted by successive administrations. Footpads and highwaymen were obviously not unheard of in early nineteenth-century Britain, but the problem was undoubtedly far more serious and widespread in Italy. Here the combination of poverty, poor government and large tracts of wild uncultivable land made travellers an easy, desirable and conspicuous target, especially when they were supposedly wealthy foreigners. They, for their part, were titillated and terrified by turns. It was one thing to enjoy – in the comfort and safety of one's home – the exploits of imaginary brigands in the seventeenth-century paintings of Salvator Rosa or to shudder at the attitudes of the swarthy ruffians of the eighteenth-century British artist John Hamilton Mortimer. It was quite another to have one's own travels curtailed by the warnings or refusals of coach-drivers and to hear tales of recent kidnapping, ransom demands, mutilation and even murder.

However, most Britons seem to have been undeterred and unprecedented numbers of artists visited Italy in the 1820s and 1830s. Furthermore, many deliberately sought the experience of 'roughing it' and being in direct contact with Italians living in remote and backward areas, a very different experience from that of

British artists in the eighteenth century, obediently trailing behind their noble patrons like pet dogs as they urbanely progressed from one civilized five-star sight to the next. Lear and Lewis, for instance, whose fame rests on their later and more distant travels and their depictions of more exotic destinations, served their apprenticeships by forays into the wilder and riskier parts of Italy. A major catalyst in this trend occurred in the summer of 1819 when the painter Eastlake and two of his friends, Captain Thomas Graham RN and his wife Maria, spent three months in the mountains near Tivoli. Here they found themselves in close proximity to the

brigands, with whom they became acquainted. Soon afterwards Maria Graham published a best-selling account of their experiences and the lifestyle of the bandits, illustrated with aquatints after drawings by Eastlake (cats. 69–70; see p. 101), and the artist himself rapidly became famous for such paintings. Sent back to London for public exhibition at regular intervals, these were instantly sold and engraved as illustrations or as individual prints, and fresh scenes commissioned (cat. 24). Eastlake's *banditti* enjoyed an enormous vogue throughout the 1820s, spawning many imitations and inspiring stories, pantomimes, operas and *tableaux vivants*.

FIG. 14 J.M.W. TURNER
Lake Albano, 1828
Watercolour, 29.2 × 41.9 cm (11^1/$_2$ × 16^1/$_2$″)
Private collection

Shelley, but no such story had originally been intended. Turner's subject was a friendly encounter between a bandit with his girl (both in characteristic costume) and a visiting painter. May we perhaps regard this dark-haired youth, with his knapsack, broad-brimmed hat and bundle of sketches, as an affectionate portrait by Turner of his much younger friend – a humorous acknowledgement of Eastlake's runaway success in an unexpected quarter? The resemblance (see fig. 15) is certainly very striking.

Both Eastlake and Turner based their bandit scenes on the art of the past, but in very different ways. Turner's landscape is thoroughly Claudian but its inhabitants are far removed from the graceful figures of gods and heroes that Claude had shown; they are, instead, the sort of slovenly, low-life characters that Dutch artists painted in Rome in the seventeenth century (fig. 16). Eastlake, on the other hand, transforms his captive peasants into a modern-day Holy Family of remarkable sweetness and gravity. Exhausted, motionless and shel-

Most of Eastlake's imitators were minor artists whose works are lost or forgotten today and the whole episode would be simply a curious sideshow in the annals of British art but for the fact that it led to one of Turner's most dazzling Italian watercolours, *Lake Albano* (fig. 14 and cat. 58 on p. 95). Turner and Eastlake were close and life-long friends and this watercolour must have been painted shortly before the autumn of 1828 when the two artists lived and worked together in Rome. This they did in 12 Piazza Mignanelli, the very same house where Eastlake and the Grahams had lived in 1819 and where Turner himself had visited them on his first tour of Italy. Late in 1828, while Turner was in Rome, an engraving of *Lake Albano* was published in England accompanied by an Italian bandit story by Mary

tered by trees, they are the heirs of many earlier images showing the Holy Family in a pastoral setting or resting on their flight from persecution into Egypt (fig. 17).

However, Italian *banditti* had an unexpected characteristic not shared by the troops of Herod – piety. They wore crucifixes round their necks; they hung up images of the Virgin Mary in their mountain fastnesses (accompanied in cat. 24 by 'Ave Maria' roughly hacked into the bark); they refrained from attacking those going to Mass in remotely sited chapels; they reputedly offered up devout prayers for success in the lottery into which they so frequently poured their takings. According to Maria Graham, every robber carried a silver heart, containing a picture of the Madonna and Child, over his own heart; it was suspended from his neck by a red ribbon and fastened with another of the same colour to his left side. This combination of crime and devotion, vice and piety, astounded British Protestant visitors, who were already obsessed by the outward and visible signs of Roman Catholicism which met their bewildered gaze wherever they looked from the moment they first set foot in Italy. Far from their homeland – with its mono-

chrome, imageless churches and simple services with the familiar comforting words of the Bible and Prayer Book in their own language – soberly dressed Britons, like the man on the right of cat. 25, could scarcely believe their eyes or ears.

These unfamiliar customs and rituals were usually regarded with scorn and horror and this was particularly true in the years leading up to the passing of the Catholic Emancipation Act in 1829. All holders of public office in Britain, both civil and military, had been required to be practising members of the Anglican Church since the Test Act of 1673. This was repealed in 1828, freeing both Catholics and non-conformists from numerous disabilities, and the Catholic Emancipation Act was passed the following year. But, however much the spread of Catholicism in Britain was feared in some quarters, it certainly provided a rich source of material for painters visiting Italy. Superb ecclesiastical buildings were conspicuous in both town and country. Elaborately dressed priests and curiously garbed monks were constantly to be seen in the streets in long processions with torches, banners and crucifixes; often they were accompanied by mysterious hooded laymen, anonymously performing penance for their sins. Images, particularly of the Virgin and the Crucifixion, abounded not only in churches but also in shops, streets and houses and in wayside shrines, where they were venerated by all who passed, with genuflection, candles, prayers and votive offerings. Other novel sights included the confessional and the washing of the feet, both painted by Wilkie in the 1820s, while a few years later Callcott depicted young girls going in procession to their first communion. William Collins simply took one of his favourite subjects, a peasant family at a cottage door, and transported them to a pious rustic building overlooking a glorious piece of coastal scenery. *Poor travellers at the door of a Capuchin convent* (cat. 26) was sold before it even left Collins's studio for the Royal Academy, and similar new works were commissioned or sold with ease.

FIG. 17 TITIAN
The Holy Family with a shepherd, ca. 1510
Oil on canvas, 99 × 137 cm (39 × 54³/₄")
National Gallery, London

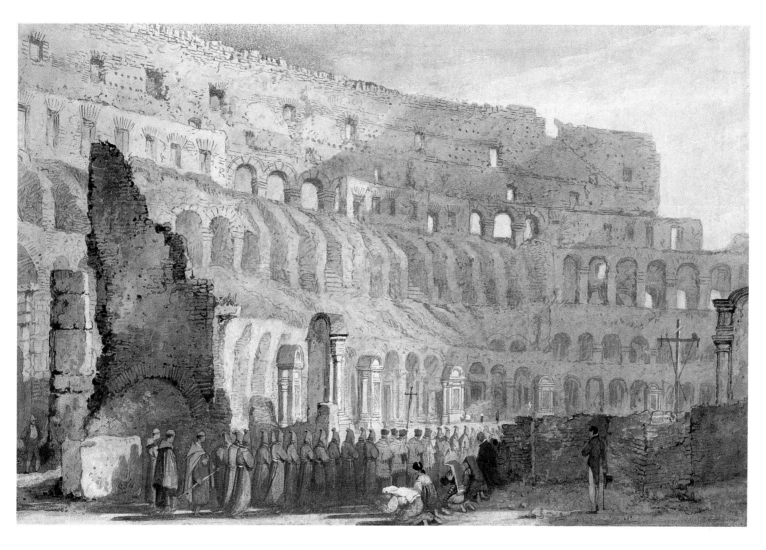

25 IMITATOR OF SAMUEL PROUT, *The interior of the Colosseum, ca.* 1830
Watercolour and bodycolour on cream paper, with penwork, gum, stopping-out and scraping-out, 22.9 × 34 cm (9 × 13³/₈″)
Victoria and Albert Museum, London

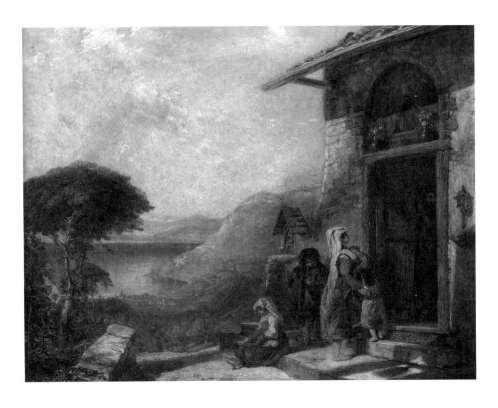

26 WILLIAM COLLINS
Poor travellers at the door of a
Capuchin convent, near Vico,
Bay of Naples, 1839
Oil on canvas, 71.5 × 92 cm
(28 1/8 × 36 1/4″)
Inscr. *W. Collins*
The Board of Trustees of
the National Museums and
Galleries on Merseyside
(Emma Holt Bequest,
Sudley House)

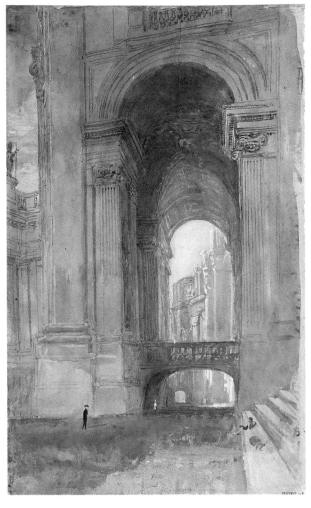

27 J.M.W. TURNER
The entrance to the via della Sagrestia, Rome, 1819
Pencil, watercolour and bodycolour on white paper prepared with
a grey wash, 36.9 × 22.9 cm (14 1/2 × 9″)
Tate Gallery, London

Pilgrims, too, were a common sight, especially at the major festivals of Easter and Christmas and in the Jubilee Year of 1825, and were often painted; Eastlake produced several versions of his much praised picture of 1827. In *Easter Day at Rome* (cat. 28) Lewis captured the typical multi-coloured dresses, strong features and orderly behaviour which had so impressed Hazlitt on an earlier occasion, but there is no sensitivity in his painting to "the expression of the dear precious shining heavenly faces" of the poor pilgrims whom Palmer watched with such compassion.[15] They are simply a crowd of very ordinary and tired characters, such as might be found on a feast day or a market day in any town in Italy. In a very different meeting between sacred and profane, looking away from the Vatican rather than towards it (cat. 27), Turner contrasted a lone cleric approaching St Peter's, a minute slip of a *contadina* and a solitary loafer on its steps. No image could express more eloquently the might, majesty and power of the Catholic Church as felt by a Protestant visitor on a first visit to Rome, or suggest with more originality the famed immensity of its greatest basilica.

Some Catholic ceremonies were very moving, some practices highly picturesque, and patrons were delighted to have paintings of these. Davis's depiction of a pious

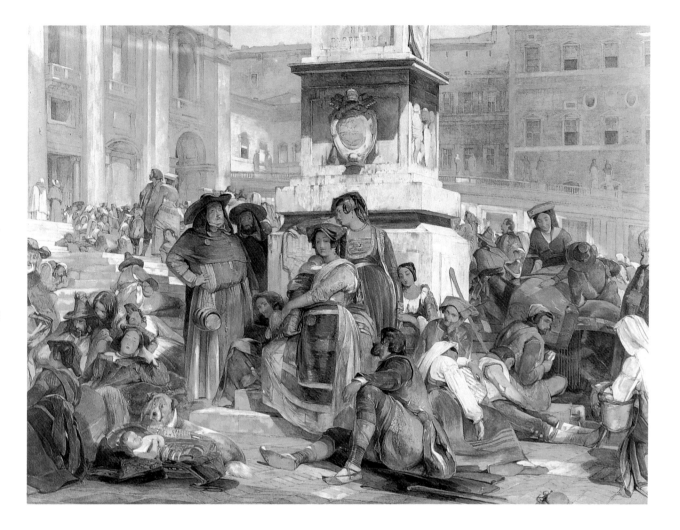

28 J.F. LEWIS
Easter Day at Rome – pilgrims and peasants of the Neapolitan states awaiting the benediction of the pope at St Peter's, 1840
Watercolour and bodycolour, 50 × 66 cm (19¹¹/₁₆ × 26″)
Northampton Museums and Art Gallery

congregation worshipping in the magnificence of St Peter's, below the mosaic copy of Raphael's *Transfiguration*, was specially commissioned (cat. 29); Uwins's *Festa of Piè di Grotta*, with its procession of graceful girls and winsome barefoot children in the beautiful setting of the Bay of Naples (cat. 30), was instantly secured by a major London dealer and connoisseur, William Seguier, on behalf of a noted picture collector. But the emotive power of such spectacles was considerably weakened by the belief, widely held by British visitors, that the Catholic Church embodied a direct continuation of the paganism of ancient Rome. Travellers could

see for themselves that the Pantheon and churches in and around the Forum were Roman temples converted into Christian shrines; books by respected British authors declared that the plethora of saints recognized (and, apparently, worshipped) in the Catholic Church had inherited the roles of the numerous gods and goddesses of antiquity; parallels were drawn between ancient and modern festivals, offerings, forms of prayers, types of superstition and every conceivable ingredient of life and religion.[16] Nothing could be more pagan than the procession of the Roman Carnival (fig. 3 on p. 13), short of the actuality of animal sacrifices and

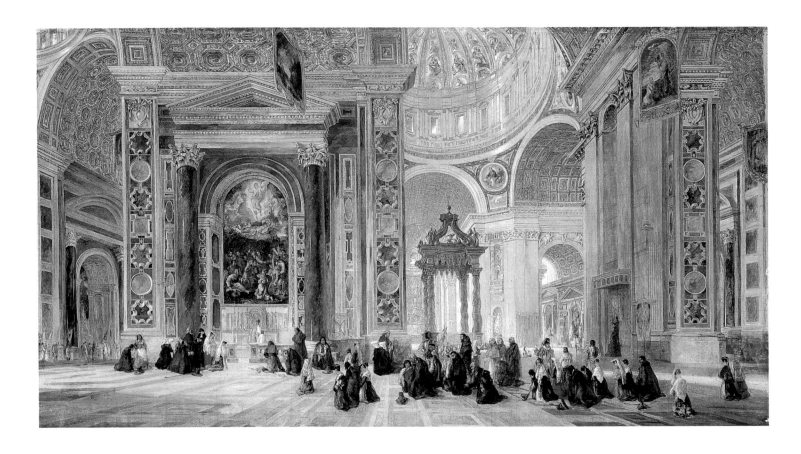

burnt offerings.

While the Italian peasants were seen as uneducated and superstitious, the priests were regarded as sly and grasping, using puppet-show theatricality with cheap and tawdry images to maintain their congregations in a repressed state of poverty and ignorance while retaining their own easy privileges. In his first exhibit at the Royal Academy after his return to England in 1831 (cat. 31), Uwins directed his scorn at the "whole machinery of Neapolitan devotion" by painting the saint manufactory, which he described as "one of the most amusing things in the city".[17] Piling on the detail with obsessive enthusiasm, he portrays the well-fed Capuchin friar "driving a hard bargain with the saint-maker", his crafty-looking companion and the helpless artisans surrounded by gaudily coloured and operatically gesticu-

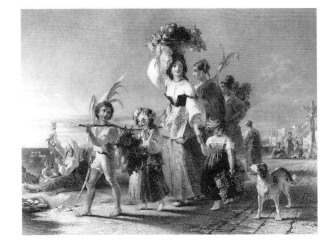

29 JOHN SCARLETT DAVIS
The interior of St Peter's, Rome, 1842–44
Oil on canvas, 60.3 × 111.8 cm (23³/₄ × 44″)
The National Museums and Galleries of Wales, Cardiff

30 S. SANGSTER AFTER THOMAS UWINS
The festa of Piè di Grotta, 1838
Line engraving on steel (after the painting of 1834), 36 × 51.1 cm (14³/₁₆ × 20¹/₈″)
Victoria and Albert Museum, London

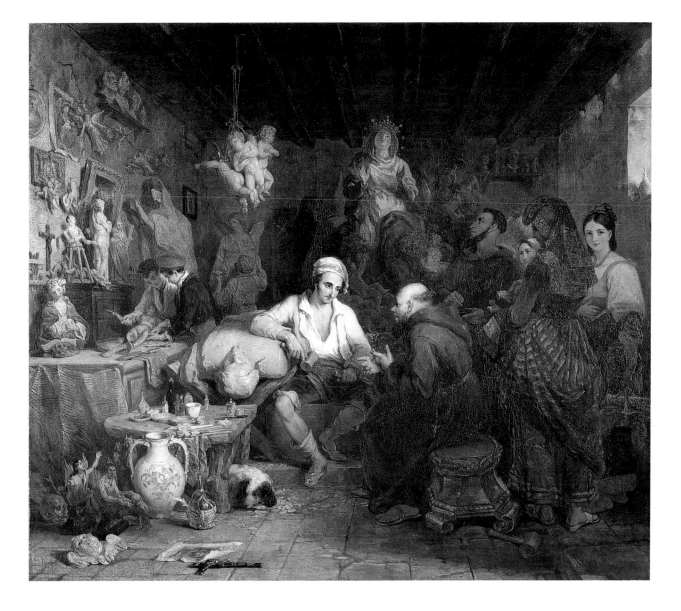

31 THOMAS UWINS
The saint manufactory, 1832
Oil on canvas, 74.9 ×
86.4 cm (29¹/₂ × 34″)
Leicester City Museums

lating statues. Against such forces, the shy *contadine*, with their beautiful and primitive simplicity, hardly stood a chance: they have trustingly "brought their household images to be newly painted and repaired".

Turner may have shared Uwins's distaste for Catholic idolatry, to judge from an unfinished painting of about this period, thought to depict *Christ driving the traders from the Temple* (Tate Gallery, London). However, a later work,

exhibited nine years after the passing of the Catholic Emancipation Act, shows a more positive approach. This was *Modern Italy – the pifferari* (cat. 32). Its pendant (*Ancient Italy – Ovid banished from Rome*, private collection) portrays the sun setting on the sordid and impious classical world; but here – in a refreshing landscape loosely based on Tivoli and the Campagna – we see a whole range of modern people and practices including the

tiny figures of the *pifferari* themselves (Calabrian shepherds who played their bagpipes before wayside images of the Madonna to relieve her labour pains), friars and priests, prayers and processions. A new era has dawned and, with it, new hope. When the painting was engraved in the early 1840s, two symbolic details were added to its foreground, at Turner's own suggestion. Both were acceptable in Protestant Britain – a baby in swaddling clothes and a bird's nest with eggs.[18]

The papal government was, of course, aware of British feelings on religious practices and it was a foolish traveller who mocked Catholicism in letters from Rome where censorship of the mail was practised. The Roman correspondence of two deeply devout Anglicans, Samuel and Hannah Palmer, contains only fleeting references to Catholicism, couched in the most circumspect phrases, and it was not until they reached Naples that Samuel expressed his horror of all the worldly pomp and show he encountered.[19] Uwins's letters to his family enabled him to unburden himself of his hatred of popish practices at frequent intervals during his long residence in the south, though, ironically, it was largely thanks to a British Catholic in Naples, Sir Richard Acton, that he was able to prolong his stay there. For Acton, whose father had been prime minister of Naples under Ferdinand IV at the turn of the century, Uwins painted pleasing and uncontroversial local subjects, such as the pair intended to provide "recollections of the delights of Naples" at the baronet's family home in Shropshire. One showed a young fisherman and a girl spinning, illustrating "the working-dress and employments of the people". The other (fig. 18) depicted "a young girl in her holiday dress, waiting with anxious expectation the coming of her lover; she has a basket of grapes in her hand, and the signal of the appointment (two green boughs crossed) is at her feet".[20] In the background is Castellamare where Acton had his villa and provided Uwins with hospitality, succour in sickness, and many useful contacts and introductions.

Another of Uwins's patrons – on a visit to Rome in 1829 – was Lord Arundel, whose father, the Duke of Norfolk, bought works by many modern British artists at this time. The heir of Britain's premier Catholic family, Lord Arundel scolded Uwins with gentlemanly good humour for the anti-Catholic feeling he found in one of his paintings; and, although personally offended by the way Uwins presented Catholicism, he agreed that it would suit the people back in England.[21] As painters of this particular aspect of modern Italy, Uwins and others certainly addressed contemporary issues at home but they were as powerless to check the flow of liberal reform as they were to check the rapid growth of Catholicism in England after the waves of Irish immigration in the 1840s. In 1842 the first Catholic lay brotherhood in London was established, swiftly followed by other holy guilds and fraternities based on devotional institutes on the Continent. In 1844 the first statue of Our Lady to be set up in London since the Refor-

NOTES

1 Lister 1974, I, p. 245.

2 In 1857 Sheepshanks (1787–1863) presented his collection of over 230 oil paintings and nearly 300 watercolours and drawings to the South Kensington Museum, now the Victoria and Albert Museum. It has unfortunately proved impossible to borrow any of these paintings for this exhibition.

3 One of the Guests' daughters became the wife of Austen Henry Layard, the excavator of Nineveh and contributor of works on Perugino, Pinturicchio and Ghirlandaio to the publications of the Arundel Society in the 1850s. After Guest died in 1852 Lady Charlotte married Charles Schreiber and together they built up the outstanding collection of English ceramics which, at his death, she gave to the South Kensington Museum.

4 Noakes 1988, p. 32.

5 Hale 1956, p. 261.

6 Lister 1974, I, p. 108.

7 Hazlitt 1826, p. 199.

8 Noakes 1988, p. 32.

9 From the text accompanying the engraving of this scene in *Heath's Picturesque Annual for 1832*, p. 169.

10 Hazlitt 1826, p. 235; Noakes 1988, pp. 45–46; Lister 1974, I, p. 128.

11 Noakes 1988, p. 45.

12 Shapiro 1972, p. 126.

13 Lister 1974, I, pp. 122, 141–42, 161–62, 217, 262.

14 Shapiro 1972, pp. 198–203.

15 Hazlitt 1826, p. 235; Lister 1974, I, p. 133.

16 For the influence of the Revd J.J. Blunt's *Vestiges of Ancient Manners and Customs, discoverable in Modern Italy and Sicily*, see Powell 1987, pp. 126, 186.

17 All quotations are from Uwins's own extended caption printed in the Royal Academy catalogue for 1832.

18 Powell 1987, pp. 186–87.

19 Lister 1974, I, p. 229.

20 Uwins 1858, I, p. 326.

21 *Ibid.*, II, pp. 145–46.

22 See S. Gilley, 'Catholic Faith of the Irish Slums. London, 1840–70', in H.J. Dyos and M. Wolff (edd.), *The Victorian City*, London and Boston 1973, II, pp. 837–53.

FIG. 18 THOMAS UWINS,
A Neapolitan girl awaiting the coming of her lover, 1826
Oil on canvas, 35.6 × 43.2 cm (14 × 17″)
Private collection

mation was erected in St Mary's, Chelsea. By the middle of the decade, processions of ordinary men and women could be seen under the sombre skies of Wapping and Deptford, wearing colourful, pseudo-medieval costumes and chanting litanies almost as if they were in Rome itself.[22]

The Legacy of Claude

By the time Turner first visited Italy in 1819 the British had been obsessed with Claude for a hundred years. In the 1720s a powerful and discriminating writer on art, Jonathan Richardson, had declared Claude's works the most beautiful landscapes in Europe.[1] British landscape painting developed in the eighteenth century largely in emulation of this seventeenth-century painter from Lorraine who had spent nearly all his working life in and around Rome, producing what must surely be the most influential landscape paintings in the history of western art. These were not straightforward depictions of Italy – indeed, place names are rare in his titles – but views of an ideal and perfect land blessed with all the most characteristic features of Italy that enchant the northerner's eye: intensely blue skies, warm and brilliant light, fertile fields and meadows, luxuriant woods, streams of crystal water, noble and ancient buildings. These ingredients are harmoniously grouped and dispersed across the canvas as if it were a stage, and among them Claude placed his characters: figures from the Bible and from classical literature and mythology.

If the countryside depicted by Claude was a land fit for heroes, it was, just as conspicuously, a subject fit for British painters. In the 1750s Richard Wilson lived and studied for many years in the same places that had earlier inspired Claude – notably Rome and the adjacent Campagna – and evolved his own version of Claude's Italy. Countless other Britons, including Wilson's own pupils, followed their example, their footsteps and, with modifications, their pictorial styles and nostalgic moods. When, in one of his Royal Academy lectures as Professor of Perspective in 1811, Turner spoke of Claude's art as "pure as Italian air, calm, beautiful and serene ... rich, harmonious, true and clear", his listeners' minds would have been filled with images of an almost magic land conjured up by an enchanter's wand: the hand – and the brush – of Claude Lorrain.[2]

Facing page Detail of cat. 33

FIG. 19
CLAUDE LORRAIN
*Jacob with Laban and his
daughters*, 1676
Oil on canvas, 72 × 94.5 cm
(28¹/₂ × 37¹/₄")
Dulwich Picture Gallery

Claude's power over successive generations of British artists and art-lovers went hand in hand with the fact that many of his works could be studied in this country. He was already being collected in Britain before his own death in 1682 and the *Jacob with Laban and his daughters* now in Dulwich (fig. 19) was one of several of his works to arrive in Britain in the early eighteenth century. Many superb examples from European collections followed, especially in the upheaval of the French Revolution and Napoleonic Wars. These included, in 1799, the exquisite pair that Reynolds had seen in Rome some fifty years earlier and pronounced much the best pictures he had seen "by this master, or indeed any other",[3] and virtually all of those now in the National Gallery. One of the latter brought tears of anger and frustration to Turner in his early twenties, despairing of his own ability ever to paint anything comparable.[4]

Claude's work was widely copied and reproduced, most crucially through the publication in London in 1777 of mezzotints after his own drawings of his paintings in the *Liber Veritatis*, itself by this date at Chatsworth. He did not, however, monopolize British visions of Italy in Turner's youth. Three other seventeenth-century landscape painters were also greatly admired and had played important parts in the birth of the British school – two distinguished northerners who worked in Italy, Nicolas Poussin and his brother-in-law Gaspard Dughet (fig. 20), creators of landscapes more stern, heroic and various than Claude's; and the Neapolitan Salvator Rosa whose wild and savage scenes were the complete antithesis of Claude's pastoral perfection. The years between Turner's two visits to Rome saw the publication of two pioneering monographs, *Memorials of the Life of Nicolas Poussin* by Maria Graham in 1820 and *The Life and Times of Salvator Rosa* by Lady Morgan in 1824. Although Palmer's mind was often on Claude while in Italy, his winter reading in Rome in early 1839 included these volumes on Rosa, stimulated by his own visit to territory associated with the artist the previous summer.[5]

Besides these painters' outstanding evocations of Italy, many others were bought by British art-lovers. Works by the 'Dutch Italianates' in particular were greatly prized at this time, as is shown by their prominence in the Dulwich Picture Gallery. In his early years in Rome Claude had close associations with his contemporaries among the Dutch painters there (Breenbergh influenced his drawings from nature, Swanevelt shared a house with him, Miel reputedly painted figures in some of his pictures) and the works of these painters and the next generation were highly regarded in Europe. Such was the power of Italy that British collectors preferred a Dutch view of Rome or the Italian countryside to a depiction of Holland by the same artist. The Italian pastorals of Berchem and Jan Both were eagerly sought after, as were Swanevelt's etchings, while the radiant paintings of Cuyp (fig. 21) – who never actually visited Italy himself – enchanted patrons, writers and painters, including Hazlitt and Turner. In 1836, in a

lecture at the Royal Institution, Constable denounced the art of the 'Dutch Italianates' as a worthless bastard, devoid of the virtues of either of its parents, but few shared his opinion. For most people, the union between bucolic Dutch naturalism and glorious Italian scenery was a marriage made in heaven.[6]

British artists visiting Italy at last after Waterloo were naturally keen to sit and sketch where their most revered predecessors had worked. They longed to penetrate their favourite haunts, to see for themselves and put down on paper their scenes and compositions. Such expectations were rarely fulfilled on a painter's first arrival. In 1837 Lear found Claude's countryside going over the Apennines from Bologna to Florence and, rather than describe to his sister the scenery of his journey, he simply told her to look at Claude's pictures, "for it is is just like it".[7] In 1819 it was not until Turner was south of Ancona and passing the small town of Osimo that he drew the pencil sketch which he annotated "The first bit of Claude". Thereafter he was often reminded of Claude, Dughet and Wilson.[8] Some twenty years later, in the south of Italy, Palmer found nothing at La Cava that reminded him of Rosa, although the artist had reputedly worked there, but thought its grand rocky hills and deep ravines, dark chasms and torrents were perfect examples of those shown by Poussin.[9] Another artist, however, who spent much longer in and around Naples, Thomas Uwins, found that Rosa really did dart upon his mind at every step he took.[10] In short, in Italy, the principles of the Old Masters became clear in landscape painting as in so many other areas of art. As Uwins remarked, Titian, Giorgione and Veronese were still there on every balcony and canal in Venice, the figures of Raphael and Michelangelo in every street and under every porch, Rosa in the environs of Naples and Claude, Poussin and Dughet in Rome and Tuscany.

But if visitors expected to find Claude's 'magical combinations' instantly presenting themselves readymade to their eyes, they were disappointed. What they

FIG. 20 GASPARD DUGHET, *Mountainous landscape with approaching storm, ca.* 1638–40
Oil on canvas, 144.8 × 221 cm (57 × 79⁹/₁₆″), Dulwich Picture Gallery

FIG. 21 AELBERT CUYP, *A road near a river, ca.* 1660
Oil on canvas, 113 × 167.6 cm (44¹/₂ × 66″), Dulwich Picture Gallery

FIG. 22 ATTRIBUTED TO CAREL DE HOOCH, *A ruined temple, ca.* 1630
Oil on panel, 16.2 × 23.7 cm (6³/₈ × 9³/₈″), Dulwich Picture Gallery

could, and did, find were the separate ingredients or prototypes, many miles apart. For Claude's Italy was a synthesis of beautiful pieces of nature, individually studied and sketched and then brought together on the canvas in response to his own imagination and idea of the beautiful itself.[11] His admirers may not have been able to rival the refinement of his tones or to achieve the profundity of his poetry, but they could easily copy this principle of selection and his methods of composition. This they did whether they had visited Italy or not, and in all manner of landscape subjects. These included both Arcadian pastorals harking back to an imaginary Golden Age and depictions of real places: John Varley's Welsh scenes; Greek views by Lear and H.W. Williams; landscapes not only of Italy itself but even of the English Lake District by John Glover, who was actually nicknamed 'the English Claude' by contemporaries, including Constable, who envied the attention he attracted. Above all, they included Turner's finest evocations of Italy, both ancient and modern, a mature example being *Childe Harold's Pilgrimage – Italy* from the 1830s (cat. 50). This and many of his other Italian scenes are "pictures made up of bits" (as he himself described Claude's paintings). Like those, they are based on "continual study of parts of nature", albeit (in the case of both painters) in diverse regions of Italy and extending over a period of years; and the parts are fused seamlessly together with a new and passionate feeling for nature itself.

Turner's *Landscape: composition of Tivoli* (cat. 33) is also constructed on the principle of selection but in a very different sense. The watercolour, which originally belonged to a noted London art collector, John Allnutt of Clapham, was painted two years before Turner first visited Tivoli and the Campagna. Just as previously Claude had selected and arranged typical subjects from Italy, so now Turner selected, modified and rearranged typical ingredients from Claude: the leafy tangle of trees, the careless and nobly elongated maidens, the cluster of lounging goats, the round classical temple

33 J.M.W. TURNER, *Landscape: composition of Tivoli*, 1817
Pencil, watercolour and bodycolour with scraping-out and stopping-out, 67.6 × 102 cm (26⅝ × 40³/₁₆″), Signed and dated 1817, Private collection

34 J.M.W. TURNER, *Tivoli: Tobias and the angel*, 1830s
Oil on canvas, 90.5 × 121 cm (35⅝ × 47⅝″), Tate Gallery, London

FIG. 23 RICHARD
WILSON, *Tivoli, the
Cascatelle and the Villa of
Maecenas, ca.* 1752
Oil on canvas, 73.3 ×
97.2 cm (28⅞ × 38¼″),
Dulwich Picture Gallery

perched above falls and stream, "the amber-coloured ether ... and fleecy skies ... every hue and tone of summer's evident heat ... aerial qualities of distance" (to quote his lecture again). Visitors to Tivoli will search in vain for Turner's view, as they would for the ruined temples that other artists have based on that of Vesta at Tivoli (fig. 22); but they may, with luck, come across at least a few ingredients proving the essential truth to nature behind it.

In *Tivoli: Tobias and the angel*, painted some twenty years later (cat. 34), Turner shows the town and its falls from a different viewpoint, in some respects similar to actual viewpoints used by Claude and Wilson (fig. 23) but also owing much to his own imagination. Turner would have been familiar with this Wilson in his youth, for it belonged in the 1790s to Dr Thomas Monro, in whose house he regularly spent evenings drawing and painting.[12] But whereas Wilson had included an artist in modern dress sketching from nature, Turner elevated the scene from the present day into the distant and heroic past by showing two figures from a story in the Apocrypha; he must have known that Claude had

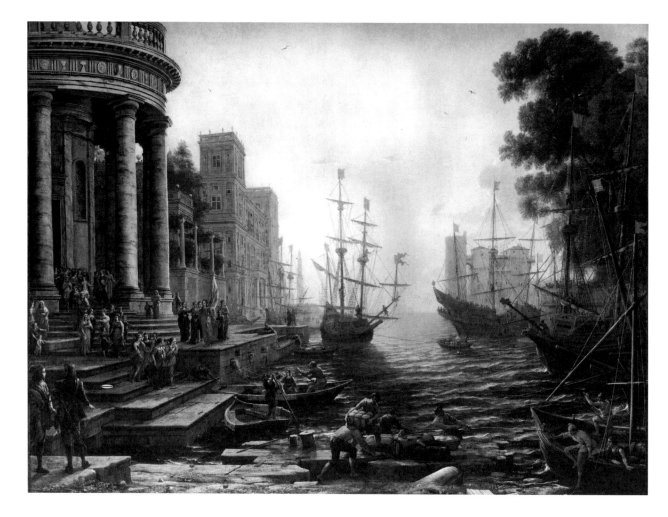

depicted the same two figures against a Tivoli back-ground, in a painting which had reached England some fifty years earlier.[13]

If Turner aimed to rival Claude's landscapes, he was equally keen to emulate his harbour scenes. It was one of the latter – *Seaport with the embarkation of St Ursula* (fig. 24) – that caused his youthful tears in 1799. Turner's *Italian bay* (cat. 35) is a preparatory work begun in a studio in Rome on his second visit in 1828 and it remains an empty stage waiting for the actors to arrive. Enlarged and enriched by further work – some tall ships against the light, small boats and busy figures in the foreground, crowds clustered on the steps on the left – this composition could easily have been transformed into a legible narrative on a par with his earlier Claude-inspired masterpiece, *Dido building Carthage* (1815; National Gallery, London). Turner produced several such oil studies during his residence in Rome, eventually finishing one of the harbour scenes and exhibiting it there along with two other paintings.[14]

Palmer admired Claude just as deeply as Turner, analysing and paying tribute to his art not in a public lecture as Turner had done but again and again in his private correspondence. He, too, fell under Claude's

spell as a very young man; on an evening walk in the 1820s, which Palmer remembered all his life, he heard the elderly Blake discoursing at length on Claude's magical depiction of foliage, speckled with tiny touches of pure white like glittering dew unreached by the morning sun.[15] At about the same time Palmer was profoundly influenced by Blake's series of small wood engravings to a school edition of Virgil's pastoral poetry, which he described as "visions of little dells, and nooks, and corners of Paradise; models of the exquisitest pitch of intense poetry They are like all that wonderful artist's works the drawing aside of the fleshly curtain, and the glimpse which all the most holy, studious saints and sages have enjoyed of the rest which remaineth to the people of God."[16]

Palmer's *Rome and the Vatican from the western hills –*

pilgrims resting on the last stage of their journey (cat. 36), shows his own sense of reverence before God and nature, in marked contrast to the pilgrim paintings of other British artists of this time (see cat. 28). It also reveals his familiarity with two of the Dulwich paintings by or after Poussin, *A Roman road* (fig. 2 on p. 11) with its broad symmetrical foreground and resting figures, and *Santa Rita of Cascia* with its bird's-eye view of a distant but clearly identifiable town at the centre of the composition (fig. 25). His pilgrims, however, are no relations of Poussin's sturdy heroes and heroines; their artistic forebears are the ethereal nymphs and timeless shepherds of Claude and Blake. Whilst in Italy Palmer expended much time and effort searching for the motifs of Claude, Dughet and Poussin (including broad and simple foregrounds and winding and dipping lanes leading the eye into the

centre of the picture, as in cat. 36), in an attempt to follow the naturalistic creed of his new father-in-law John Linnell.[17] However, as he later wrote, it was not the truth of Claude's colour or the charm of his trees or the gold of his sunshine that made him the greatest of landscape painters; nor was it an ability "to satisfy that curiosity of the eye which an intelligent tourist ever feeds". It was his power to transport the mind and the imagination through distance and time into a Golden Age, just as the greatest poets do.[18] Turner and Palmer himself both shared this ability; it was a far more important legacy than compositional formulae.

NOTES

1 *An Account of Some of the Statues, Bas-reliefs, Drawings and Pictures in Italy*, London 1722, quoted in M. Kitson, 'Turner and Claude', *Turner Studies*, II, no. 2, 1983, pp. 2–15; see also D. Howard in *The Art of Claude Lorrain*, exhib. cat., ed. M. Kitson, Newcastle, Laing Art Gallery, 1969, pp. 9–10.

2 Turner's lecture on 'Backgrounds: Introduction of Architecture and Landscape' was published by J. Ziff, *Journal of the Warburg and Courtauld Institutes*, XXVI, 1963, pp. 124–47. See also K. Nicholson, *Turner's Classical Landscapes*, Princeton 1990, chapter 6.

3 C.R. Leslie, *Life and Times of Sir Joshua Reynolds*, London 1865, I, pp. 53–54.

4 Kitson 1983, *op. cit.*, p. 5.

5 Lister 1974, I, p. 284.

6 *Italian Recollections: Dutch Painters of the Golden Age*, exhib. cat. edd. F.J. Duparc and L.L. Graif, Montreal Museum of Fine Arts, 1990, pp. 14–16. See also Hazlitt's enthusiasm for the Cuyps at Dulwich in *The London Magazine*, January 1823.

7 Noakes 1988, p. 29.

8 Powell 1987, pp. 29–31.

9 Lister 1974, I, p. 173.

10 Uwins 1858, II, p. 117.

11 Compare Lister 1974, I, p. 174 (1838) and II, p. 894 (1874).

12 Another version of this painting in the Turner Bequest (Tate Gallery 5538) has been attributed to Turner himself, but is generally thought to be by Wilson or one of his circle.

13 See Powell 1987, pp. 169–70.

14 *Ibid.*, pp. 159, 141–56.

15 Lister 1974, II, p. 573.

16 *William Blake*, exhib. cat. ed. M. Butlin, London, Tate Gallery, 1978, pp. 138–41.

17 Lister 1974, I, pp. 329, 344.

18 *Ibid.*, II, pp. 913, 923–24.

FIG. 25 NICOLAS POUSSIN
Santa Rita of Cascia, ca. 1635–40
Oil on panel, 48.8 × 37.8 cm (19¼ × 14⅞″)
Dulwich Picture Gallery

36 SAMUEL PALMER, *Rome and the Vatican from the western hills – pilgrims resting on the last stage of their journey, ca. 1838–45*
Watercolour, bodycolour and ink on buff paper, lightly squared in pencil, 52.3 × 71.6 cm (20⁹⁄₁₆ × 28³⁄₁₆″), The Syndics of the Fitzwilliam Museum, Cambridge

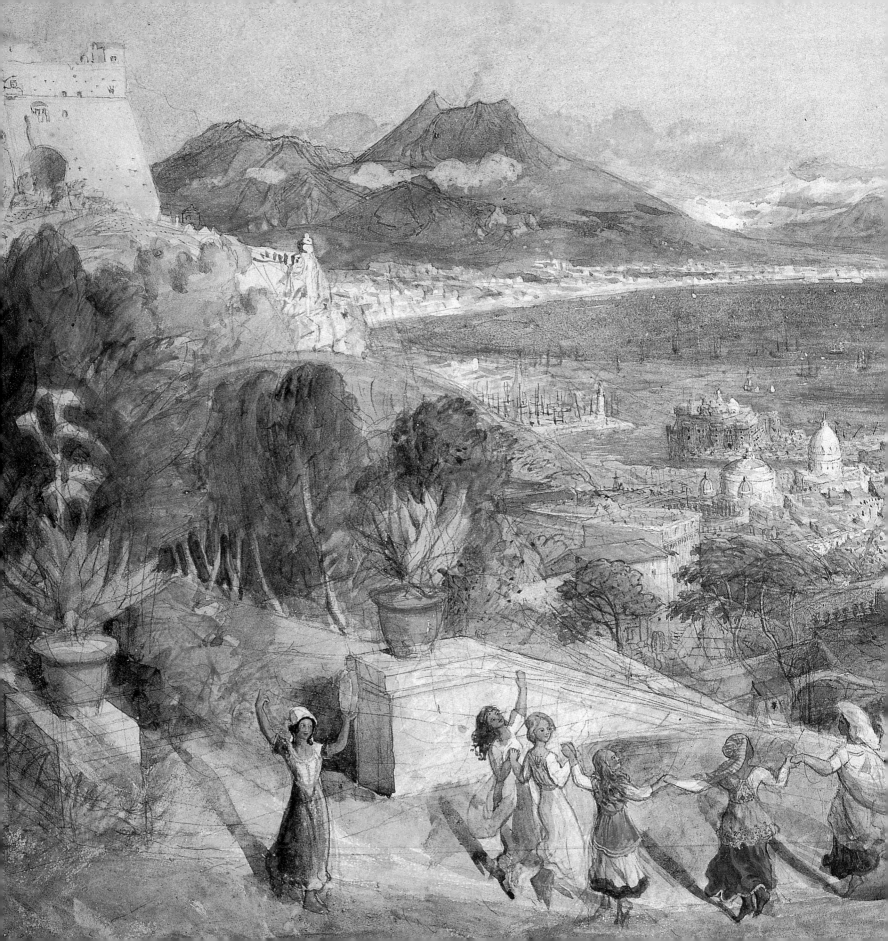

The Warm South

Turner and his contemporaries found it much easier than their predecessors to cross the icy barrier of the Alps into the cloudless climes of the south. Ironically this benefit, like the sight of the new-found ruins of Rome and Pompeii, was the result of Napoleon's Italian campaigns. In May 1800 Napoleon himself had made a historic three-day crossing into Italy, with some 40,000 men, using the Great St Bernard Pass, and went on to win an important victory over the Austrians at Marengo, north of Genoa, just a month later. Napoleon's triumphalist pose in Jacques-Louis David's celebration of this famous crossing of the Alps was echoed by Turner in 1827 (cat. 37 and cat. 59 on p. 95). The Simplon Pass, linking Switzerland to Italy, was planned immediately after the events of 1800 and opened in 1805; a new carriage road was constructed through the Mont Cenis Pass, between France and Italy, in 1803–13. Despite these innovations, the Alps still presented a formidable challenge to travellers from the north. It was with huge relief that, after weeks or even months of travel, they at last reached the balmy air of Italy, the ravishing scenery of Lake Maggiore and the fertile plains of Lombardy, and felt the south wind, "warm to the hand like the air from a heated pipe".[1] Their sense of achievement is nowhere better expressed than in the wide expanses of Callcott's painting for John Soane, *The passage point* (fig. 26). Produced soon after the painter's extensive tour of Italy, it brings together many of the typical and reinvigorating motifs that every weary traveller must have longed for.

As in the eighteenth century, visitors often made a circular tour dominated by the famous cities of Venice, Florence, Rome and Naples. Many ventured south of Naples as far as Paestum (cat. 61 on p. 96) and a few fearless souls like Lear explored Sicily, finding ruins even older and vaster than those on the mainland. In the years just after 1815, most travellers were content to see the quintessential Italy, known to them through paintings, narratives and engraved illustrations, and

Facing page Detail of cat. 38

37 J.M.W. TURNER
Marengo, *ca.* 1827
Watercolour vignette, 21.4 × 29.8 cm
(8⁷/₁₆ × 11³/₄″)
Tate Gallery, London

FIG. 26 A.W. CALLCOTT
The passage point: an Italian composition, 1830
Oil on canvas, 106.3 × 215 cm (42 × 85″)
Sir John Soane's Museum, London

regions with entirely divergent characters were, on the whole, of little interest. The south was epitomized, above all, by the Bay of Naples and the Roman Campagna. In the 1820s Prout and Bonington became the first British artists to paint Venice in earnest (as opposed to simply sketching it), closely followed by Stanfield and Turner in the 1830s and thereafter by many others seeking to capture its splendour and fragility. Paradoxically, as the century progressed and Italy itself came nearer and nearer to political unification into a single kingdom, the word 'Italy' conjured up more and more diverse visual images to the Britons who loved her. The classical world never meant anything to Ruskin, for whom mountains were an abiding passion. In 1845 he declared that there was nothing in the south of Italy half so Italian as Lake Maggiore: the great serpentine lake, set in its rich and majestic landscape of mountains and luxuriant woods, was far more potent than Florence with its "stunted olives".[2]

The warmth of Italy was an immediate delight after the Alpine snow, especially to those arriving in spring or autumn. February might feel as balmy as April in England and fortunate artists found they could sketch comfortably out of doors in Rome and Tivoli even in December. But Italy's climate had many unforeseen problems and dangers, the extremes of both summer and winter being equally hard for the English to handle, and painters who came for an extended stay often ran into serious trouble. Florence could be bitterly cold, with the added burden of an icy wind. Wintering in Rome, visitors were appalled at the intensity of the cold and the fact that their marble-floored rooms frequently had no fireplaces; Samuel Palmer described Hannah as being "wrapped up like a mummy". for months and on a particularly bad March night in 1839 their lodgings were so cold that he wore two flannel-lined waistcoats, a flannel gown, two frock coats and, finally, a waterproof cloak.[3] Not surprisingly, both Hannah Palmer (barely in her twenties) and Maria Callcott (in her early forties) suffered from poor health all too frequently on their Italian honeymoons.

Things became even more difficult in the summer. It was impossible to remain in Rome in the burning heat and refuge had to be sought in a hilly or coastal area. Even there, the precise spot had to be chosen carefully and life itself modified. The Palmers suffered terribly from the heat wherever they went and sorely lamented the months of wasted time; though their watercolours seem brimming over with joy and pleasure, they often include unfinished or unresolved passages (cat. 38). The Collins family fared even worse than the Palmers. In 1837 they went to Sorrento, as being healthier than Naples, but William foolishly refused to adopt the habit of the siesta and reduce the hours he spent sketching out of doors, maintaining, "he had not come all the way to Italy to go to sleep in the daylight." The result was sunstroke combined with a very severe bout of rheumatic fever affecting all his limbs and incapacitating him for nearly six months. When his health was at last improving, he declared that he "would not venture to live in Southern Italy during another summer; even to be as great as Turner himself."[4] (In fact, Turner avoided Collins's difficulties by usually arriving only in September or October and, in the case of his two longest visits in 1819 and 1828, leaving very early the following January.) Besides being "roasted by day and boiled by night" (as Palmer put it),[5] everyone suffered agonies from fleas and mosquitoes; the sulphurous air of Naples made Lear cough and spit blood so that he had to return to Rome; Albin Martin, the painter who eventually came out from England to help the Palmers complete Linnell's formidable copying tasks in the Vatican, became ill again and again, merely compounding their problems. The information that 1839 was Italy's hottest summer for twenty years can have been little comfort.[6] However, none of the British artists in Naples in the late 1830s succumbed to the cholera that swept through that city, and the two painters who had originally gone to

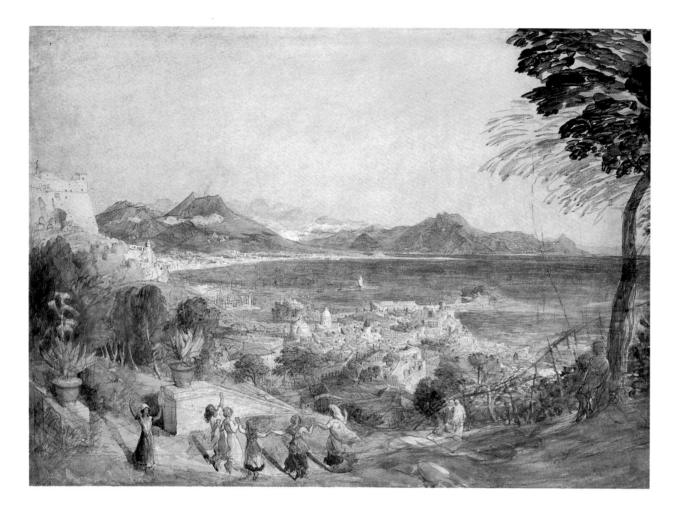

38 SAMUEL PALMER
The Bay of Naples, 1838
Pencil, watercolour and
bodycolour on paper,
42 × 58.2 cm
(16½ × 22⅞")
Agnew's, London

Italy for the sake of their health, Uwins and the epileptic Lear, derived positive overall benefit from the warmth of the south. Throughout the period ailing Britons continued to visit Italy in search of relief or cure. A great many died there, like Keats in 1821, and the epitaphs in the Protestant Cemetery by the walls of Rome are moving reminders that the pursuit of health had a very high failure rate.

As William Collins's experience so painfully illustrates, working in the open air was of prime importance to artists in Italy. When too weak to move, he had to be satisfied with drawing the Bay of Naples from his window as, also, did Hannah Palmer when her hus-

band was too busy to chaperon her outside.[7] However, most were more fortunate. Turner, Samuel Palmer and J.D. Harding never went out of doors in Italy without a small sketchbook in their pocket, so that every striking sight was swiftly committed to paper; larger sketchbooks and sheets of paper were also used. Artists sketched in the streets and in the hills. They sketched from gondolas in Venice, where Collins was piloted to picturesque spots by Byron's former cook Beppo in 1838.[8] The elderly Turner was observed hard at work there one evening in 1840 by a young watercolourist on his first visit to Italy, William Callow; not surprisingly, Turner's industry made Callow instantly ashamed of

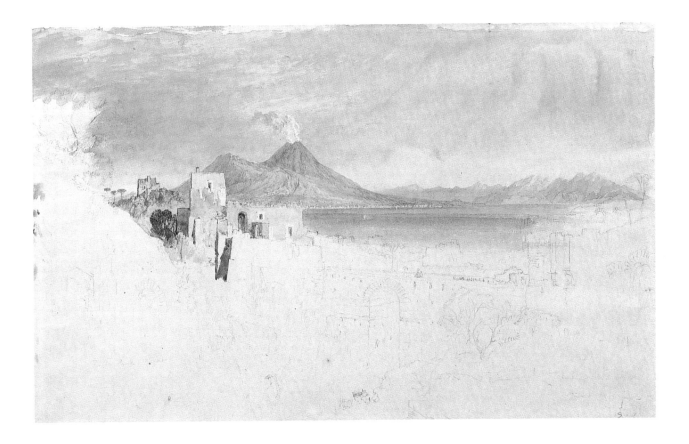

39 J.M.W. Turner,
Vesuvius, 1819
Pencil, partly finished in
watercolour, on white
paper, 25.5 × 40.5 cm
(10 × 16″)
Tate Gallery, London

his own idleness in merely enjoying his gondola, the brilliant sunset and a cigar.[9]

It was easy to appreciate the beauties of the south – the rich, saturated colours, the abundant vegetation, the clarity of the air, the luminosity that burnished every building, the sharp contrasts of light and shade. It was not so easy to record them. In bright sunlight artists often found it less taxing to sketch on tinted paper than on white (cats. 8, 16, 52) and many experimented with several different tints – green, grey, blue and brown. They also found it easier just to make pencil drawings and verbal colour notes out of doors and do the more intricate and time-consuming work of colouring back in their lodgings (cat. 39). There the brilliance of the light did not wreak havoc with their sense of colour and the heat did not sap their strength. In a famous

encounter recorded in one of John Soane the younger's letters to his father, Turner was invited to go out colouring in Naples in 1819 with an ambitious young painter who was doubtless hoping to pick up a hint or two on the side. Turner refused, somewhat curtly, on the grounds that colouring in the open air took too long and he could draw fifteen or sixteen pencil sketches in the time needed for a single coloured one.[10] Moreover, the colours of nature itself were changing every minute, as Callcott later remarked to Palmer, so that "a picture done out of doors must needs be false ... distances and mountains never know their own minds ten minutes together."[11]

Turner nearly always preferred solitude when working and rarely sketched in company. Other Britons, including the Palmers, found themselves living in com-

munities of artists and working in veritable sketching parties of a dozen or more from different nations (cat. 40). Penry Williams's drawing includes not only the bonnetted Hannah and bespectacled Samuel but also the hapless Albin Martin, propped up against a rock and shielded by a vast sunhat, and the lanky Edward Lear, knees to his chin in an awkward pose worthy of Monsieur Hulot.[12] All were staying at Civitella, some thirty miles east of Rome, and working in the wild and wooded hilly area close to the medieval town of Olevano Romano. Their subject on 1 July 1839 was, as the comic news headline of the *Civitella Gazette* shows, the Serpentara: a piece of dramatic rolling countryside with rocky outcrops, superb groves of oak trees and a complex mountain distance (cat. 41). The area had been discovered by French and German artists at the very beginning of the century and was the focus of much study in the 1820s.[13] One of the artists participating in the early visits to Olevano Romano had been the Amer-

ican Washington Allston, resident in Italy from 1805 to 1808, who later spent several years in England, becoming especially friendly with William Collins.[14]

Despite all the problems of working outside in the warm and luminous south, many northern painters were convinced of its importance.[15] It was an essential step in the achievement of naturalism, as Italy's own painters had discovered back in the Renaissance. In the seventeenth century Rosa and others had made oil sketches from nature in and around Naples. The British believed that their idol Claude had painted out of doors in Rome and the Campagna. They also knew from the writings and remarks of Sir Joshua Reynolds and his contemporaries that another painter celebrated for his wondrous light effects, Claude-Joseph Vernet (fig. 27), had done so in the eighteenth century and recommended it to visiting British artists. In Rome and Tivoli, Civitella and Olevano, and countless other spots, they could see for themselves the Continental artists of their

41 PENRY WILLIAMS
*Olevano Romano and the
Serpentara*, 1839
Watercolour, pen and ink
on paper, 23 × 33 cm
(9 × 13″)
The British Museum

FIG. 27 CLAUDE-
JOSEPH VERNET
An Italianate harbour scene,
1749
Oil on canvas, 104.4 × 117.8
cm (41⅛ × 46⅜″)
Dulwich Picture Gallery

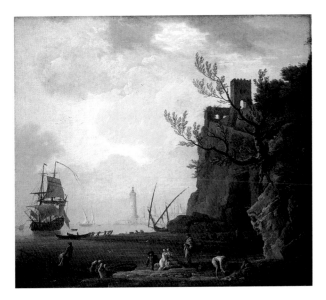

own day making oil sketches from nature as part of their academic training or regular practice. These were, of course, private works, made to promote a painter's personal development rather than his public image. Further pressure was exerted by the example – or supposed example – of earlier British painters in Italy such as Thomas Jones and Richard Wilson. The artist at the easel in Wilson's painting of the Cascatelle at Tivoli (fig. 23 on p. 63) was widely regarded as a self-portrait, as Joseph Farington believed and recorded when he was shown it by its owner, Sir Peter Francis Bourgeois, in 1809.[16] The ill-fated William Collins would certainly have known this painting, for his brother Francis had unsuccessfully applied for the post of Keeper at the

FIG. 28 C.L.
EASTLAKE
View near Rome (detail from
a panoramic sketch)
ca. 1816–20
Oil on five pieces of paper
mounted on canvas, 34.3 ×
172 cm (13$^{1/2}$ × 68″)
Agnew's

Dulwich Picture Gallery in 1821.[17] If he regarded the picture as evidence of Wilson's own habits, he failed to take into account the different conditions of Tivoli in the spring and southern Italy in July. Collins naively imagined that it was essential to paint his picturesque Sorrento models in the open air of his own terrace or garden "in order that they might lose nothing in his hands of that bright glow of air and daylight which had shone over them when he first beheld them at the doors of their dwellings, or among the plants in their vineyards."[18] In fact, Wilson firmly believed that monochrome sketches and an artist's memories of colour were far more reliable than coloured sketches; and, in any case, some of Thomas Jones's startling and original oil sketches of Neapolitan roofs and walls were painted from his own "very cool and pleasant" lodgings in the month of May, some in December.[19]

Two British artists in Italy in 1815–30 were particularly influenced by the procedures of foreign artists and painted oil sketches out of doors with striking success. Eastlake enjoyed close links with the foreign artists' colony in Rome throughout his long sojourn there and was intensely interested in their practice. He made landscape studies indefatigably out of doors in the summer (fig. 28), spending weeks at a time at Tivoli, Subiaco and other popular spots and earning himself the nickname of 'Salamander', until checked by his health in 1820.[20] Bonington, on the other hand, had lived in France since his youth and received his artistic training there. He was influenced towards oil sketching by a French contemporary, Paul Huet, but a catalyst of equal importance was the discovery, on his visit to London in 1825, of a means of making oil sketches out of dooors a much simpler operation than it had been hitherto. This was the millboard specially prepared with an off-white gesso ground by the colour merchant R. Davy in Newman Street. It was rigid but easily portable on a tour and with just the right reflective properties for sketching in Italy,

as can be seen from Bonington's use of the board in the spring of 1826. Thanks to the prepared millboard, a sketch such as *Entrance to the Grand Canal* (cat. 42) could usually be completed in a single sitting: rough graphite drawing (visible above the roofs on the left) was followed by the swift blocking-in of buildings in very light colours, which was skimmed over with darker details just before it was dry.[21]

Turner also produced oil sketches in Italy – ten small ones on millboard or muslin mounted on millboard, and sixteen that are twice as large and painted on canvas (cat. 35 on p. 65) . It is tempting to think that he painted these in the open air but this would not have been typical; his occasional experiments in this mode had all been made in the softer light of England many years earlier. The ten on millboard may perhaps have been executed in the open air in November 1819, with Eastlake's encouragement. Those on canvas are certainly studio works, painted in the rooms he shared with Eastlake in 1828; Turner's second visit, in contrast

43 EDWARD LEAR
Paliano, 1838
Black chalk and white
bodycolour on blue-grey
paper, 24.4 × 34.5 cm
(8⅝ × 13½″)
Inscr. *Palliano. 1838.*
E. Lear del.
Victoria and Albert
Museum, London

to his first, was devoted to working hard indoors (he completed three substantial paintings in three months) and Eastlake would undoubtedly have warned him off too much sketching in strong sunlight with the cautionary tale of his own recurring eye problems.

While colouring presented some difficulties of execution, monochrome drawings evoked warmth and light extremely effectively, as had been famously shown by Claude and Wilson. In Lear's study at Paliano, near Olevano – as in many of his other drawings and lithographs – he stresses the interminable, blindingly hot walk between hilltowns by including a sumptuous rendering of a vast and darkly spreading tree, one of his favourite subjects (cat. 43). As Ruskin sat on a rock and sketched the stone pines at Sestri Levante (fig. 29), the trees screened his view of the bright sky and the coast south of Genoa. But the warmth of the April day and the purity of the air are strongly felt in his drawing; the viewer knows, even without reading Ruskin's own account, that the day was windless and the air scented with pines and wild flowers.[22]

With watercolours, too, economy in the colours often produces more radiance and sparkle than a bouquet of many hues; Prout and Bonington often captured the feel of Italy's sun-drenched buildings and streets with very restricted palettes and rigorous control of bright

FIG. 29 JOHN RUSKIN
Stone pines at Sestri, Gulf of Genoa,
1845
Pencil and pen with watercolour
and white bodycolour on paper,
44 × 33.5 cm (17$^{1}/_{2}$ × 13$^{3}/_{16}$″)
Ashmolean Museum, Oxford

FIG. 30
R.P. BONINGTON
Corso Sant'Anastasia, Verona, 1826
Watercolour and bodycolour
over pencil on paper, 23.5 ×
15.8 cm (9$^{1}/_{4}$ × 6$^{1}/_{4}$″)
Victoria and Albert Museum,
London

44 R.P. BONINGTON
The Castelbarco Tomb, Verona, 1827
Pencil, watercolour and bodycolour on white paper,
19.1 × 13.3 cm (7$^{1}/_{2}$ × 5$^{1}/_{4}$″)
Inscr. *R.P.B. 1827*
City of Nottingham Museums: Castle Museum and Art Gallery

focal points. Their works show how heat and light can destroy colour as well as enhance it, bleaching wood-work and paint and causing other materials to fade, peel and decay. In his view along the Corso Sant' Anastasia in Verona (fig. 30), Bonington had little inter-est in either the architecture or the street life. He was concerned with giving a dynamic impression of sunlight and shadows in a narrow street filled with irregular houses and ending in a light-filled piazza. Contrast and pattern are his theme again in *The Castelbarco Tomb, Verona* (cat. 44), with the subject suddenly exposed against the sky between tall dark flanking screens as

monuments in Italy so often are. Lear, too, knew how to achieve the unexpected. In *Church of Santi Quattro Coronati, Rome* (cat. 45), he selected strange, sensuous colours and left the bare paper to shine forth here and there as if gleaming in the sun. The ground seems to have melted in the heat, the building burnt to a crisp. All three were masters also at depicting shadows – sud-den sharply defined areas of bizarre shape, soft patches of deep colour, cavernous black voids. Palmer some-times used gold in his paintings and knew the impor-tance of well placed white highlights. Turner could evoke every nuance of the warm south from the inno-

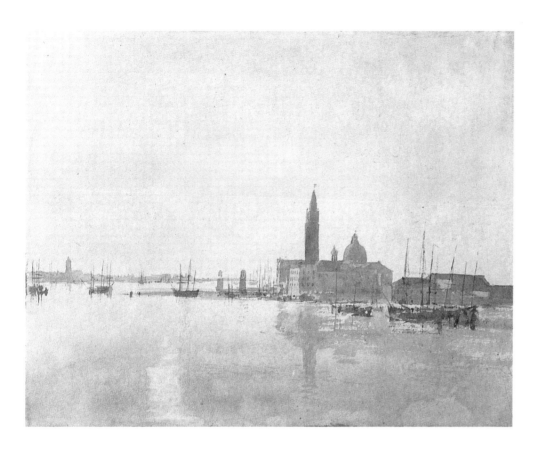

cent, pearly morning of his swift sketch of Venice (cat. 46) to blinding midday heat and on to sultry afternoons bathed in liquid gold (fig. 14, p. 46), moonlit evenings haunted by horrors of the past (cat. 16 on p. 32), and romantic nights too brilliant and hot for remaining indoors (cat. 47 and cat. 62 on p. 96). The light and heat of Italy dictated its own themes, set its own problems and inspired its own solutions.

High among the favourite themes of the artist in the south was water, serene cool mirror of the brightness all around, refreshing to skin, ear and spirit alike. How much there was to enjoy: the canals and lagoons of Venice and its islands; the gloriously rugged coast from Genoa down to Pisa; the azure expanses of the Bay of Naples, girdled with trees and bright buildings and either crowned or threatened – as different artists saw

it – by the distant peaks of Vesuvius. There were the grand lakes of northern Italy with their backdrop of snow-clad mountains; the smaller lakes of Albano and Nemi, glittering like jewels in the ancient crater hollows of the densely wooded hills near Rome; the complex music of the ornate Baroque fountains of Rome; the tinkle and plash of the humbler life-giving springs and fountains in towns and villages; the roaring of natural cascades and waterfalls like those at Tivoli, where Wilson had reputedly exclaimed, "Well done, water, by God!"[23] Many must have plunged into lakes or the sea, quite "knocked up" by the heat like Turner at Marseilles after his long journey through France in the summer of 1828.[24] However, the refreshing waters of the Mediterranean were unpredictable and treacherous, as Shelley found to his cost when sailing from Lerici in the

46 J.M.W. TURNER
San Giorgio Maggiore, Venice: morning, 1819
Watercolour on white paper, 22.3 × 28.7 cm
(8³/₄ × 11¹/₄″)
Tate Gallery, London

47 J.M.W. TURNER
A villa (Villa Madama – moonlight), ca. 1827
Watercolour vignette, 24.1 × 29.7 cm
(9¹/₂ × 11¹¹/₁₆″)
Tate Gallery, London

Gulf of La Spezia on a fateful day in July 1822. In Turner's ravishing Neapolitan watercolour studies of 1819 showing the Castel dell'Ovo and Capri (cat. 48), he depicted sea, sky and land in countless different tints and in many moods – ominous, serene and golden. The invalid Collins recorded the same transitions from his window in the course of a single day.[25]

Gardens, too, like those of the Villa d'Este at Tivoli (cat. 49), were a joy for visitors as they had been for those who created them centuries before; innumerable artists have found pleasure and inspiration in their shady walks, huge trees and ornamental waters. The Boboli Gardens provided welcome relief from the cramped and severe streets of Florence, while the gardens of the great villas of Rome offered peace and tranquillity after the bustle of the city together with many fine viewpoints. When Byron described Italy as "the garden of the world" in the fourth canto of *Childe Harold's Pilgrimage* in 1818, he was not just evoking nature's own fertility, unchecked in a country in decline. He was appealing to every reader's vision of a refuge from the cares and pressures of the world, a place of natural refreshment, of dreams and reveries, of enticing vistas and ambiguous distances. Turner's enormous painting (cat. 50) was

48 J.M.W. TURNER
The Castel dell'Ovo and Bay of Naples, 1819
Watercolour on white paper, 25.5 × 40.4 cm
(10 × 15⅞")
Tate Gallery, London

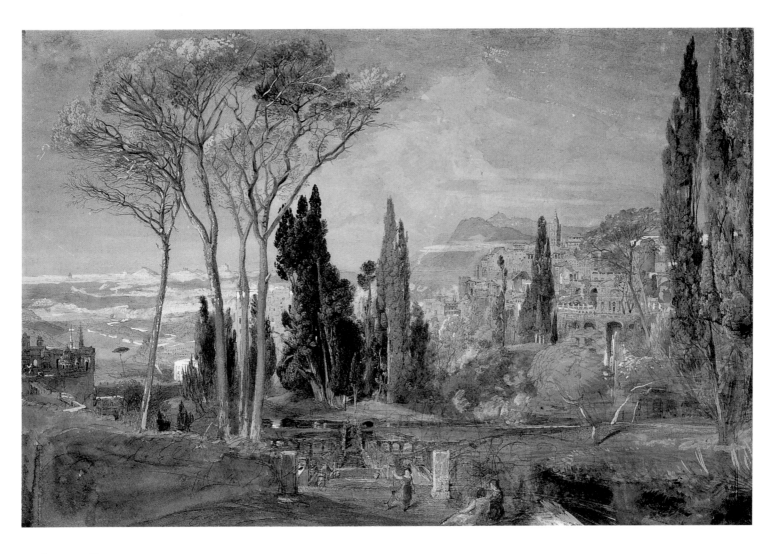

49 SAMUEL PALMER
Villa d'Este, Tivoli, ca. 1838–39
Pencil, watercolour and bodycolour, reinforced with pen and ink, heightened with gold, on buff paper, 33.5 × 50.4 cm (13^{1}/$_{4}$ × 19^{7}/$_{8}$″)
The Visitors of the Ashmolean Museum, Oxford

exhibited with a quotation including this phrase in 1832, six years after the poet's death. Against a landscape background that seems to reach back as far as Italy itself, Turner captured one tiny moment in the history of this immense garden where so many generations of children have skipped and frolicked, so many generations of women have looked eagerly forward and fondly looked back.

Italy was seen by most of Byron's readers as an earthly paradise, a land which, despite its many inconveniences, gave a foretaste of heaven. It was full of exotic, unfamiliar, seemingly impossible sights, created by the toil of mankind. In the north were the Venetian palaces rising from the water, whose intricate façades,

tinged with Oriental splendour, were captured by Prout (cat. 51), or the islands of the Venetian lagoon, tiny remnants of past glory, evoked by Stanfield (cat. 57 on p. 93). In the south stark white villages gleamed in glorious settings, as in Williams's *Pozzuoli* (cat. 53), or sprang unadorned and miraculously from cliffs and crags, as in Lear's *Amalfi* (cat. 52). There were also sights in which man had played no part, areas of utter wildness, barrenness and seclusion that were a far cry from the painted world of Claude and Wilson. "Every landscape painter should see Italy," wrote Palmer in 1838. "It enlarges his idea of creation and he sees ... the sun and air fresh as from the hand of their maker."[26]

But just as the Garden of Eden had its serpent, so,

50 J.M.W. TURNER
*Childe Harold's Pilgrimage –
Italy*, 1832
Oil on canvas, 142.2 ×
248.3 cm (56 × 97¾")
Tate Gallery, London

51 SAMUEL PROUT
Venice, the Palazzo Contarini-Fasan on the Grand Canal, 1840?
Watercolour and bodycolour on white paper, with penwork, scraping-out
and scratching-out, 43.4 × 30.2 cm (17 × 12″)
Victoria and Albert Museum, London

52 EDWARD LEAR
Amalfi, 1838
Black chalk and white bodycolour on blue-grey paper, 34.2 × 25 cm
(13¹/₂ × 9⁷/₈″)
Inscr. *AMALFI. E.LEAR. del. 1838*
Victoria and Albert Museum, London

53 PENRY WILLIAMS
Pozzuoli, 1831
Oil on paper on canvas,
27.9 × 41.9 cm
(11 × 16½″)
Inscr. *Pozzuoli 1831*
The National Museums and
Galleries of Wales, Cardiff

FIG. 31 NICOLAES BERCHEM
Roman fountain with cattle and figures, ca. 1645
Oil on panel, 36.8 × 48.4 cm (14¹/₂ × 19¹/₂″)
Dulwich Picture Gallery

too, did the earthly paradise that was Italy. Few Britons needed Byron to tell them,[27]

What men call gallantry, and gods adultery,
Is much more common where the climate's sultry,

for Grand Tourists and their entourages had enjoyed this aspect of Italy for themselves. The visiting British painters of the early nineteenth century seem to have been more prudent in their behaviour, though they can have had no illusions on this subject. This was certainly true of Thomas Uwins, who spent longer in southern Italy than any previous British artist and then – in a period of increasing emphasis on work, purity and respectability – went on to produce exercises in moral didacticism rather than mere views or simple genre scenes. In one of these painted sermons, *The favourite shepherd* (Victoria and Albert Museum, London), the

village girls drawing water near La Cava are much more interested in flirtation and gossip than in their tedious daily chores; their minds are full of far more diverting activities than Berchem's untidy *contadine*, hard at work on hands and knees or pausing wearily to draw breath (fig. 31), seem to have ever dreamed of. The pretty child learning the tarantella from her mother in another Uwins painting, *The lesson* (fig. 32), will soon be mastering the arts of coquetry and seduction as well as the steps of this immodest and unladylike dance (a British infant would, of course, have used the time more profitably, quietly listening to Bowdler's *Family Shakespeare* while embroidering pious texts on her sampler). In a third painting, with a very different focus, *The saint manufactory* (cat. 31 on p. 53), Uwins reminds his viewers of the lasciviousness of the Italians by including a small version of a notoriously erotic image. There she stands on the cupboard on the left, deliciously wriggling out

FIG. 32 THOMAS UWINS, *The lesson*, 1842
Oil on panel, 43.5 × 55.9 cm (17⅛ × 22″), Victoria and Albert Museum, London

of her draperies in amongst all the Catholic images: the Callipygian Venus, a classical statue in the Naples museum which by the 1830s was virtually synonymous with indecency.[28] Her indelicacy was exceeded only by the priapic wall-paintings and statuettes found at Pompeii, which aroused horrified condemnation tainted with prurient curiosity. The sudden destruction of that city, caught in the fiery path of the bubbling red-hot lava of Vesuvius (cat. 14 on p. 31), was declared by some Britons to be no less than divine justice, an appropriate punishment for all its moral degradation, cruelty and vice, rivalling those of Rome itself.[29] Few nineteenth-century Britons had seen a volcano in full eruption, but they were certainly familiar with the concept of hell-fire and damnation.

NOTES

1 E.T. Cook and A. Wedderburn (edd.), *The Works of John Ruskin*, 39 vols., London 1903–12, I, p. 379.

2 Shapiro 1972, p. 157.

3 Lister 1974, I, pp. 215, 313.

4 Collins 1848, II, pp. 105–17, 125.

5 Lister 1974, I, p. 353.

6 *Ibid.*, p. 364.

7 Collins 1848, II, pp. 115–16; Lister 1974, I, p. 142.

8 Collins 1848, II, pp. 148–49.

9 J. Reynolds, *William Callow R.W.S.*, London 1980, p. 73.

10 Powell 1987, p. 50.

11 Lister 1974, II, pp. 821–22.

12 For the Palmers' own account of their time at Civitella, see their letters of 30 June and 10 July in Lister 1974, I, pp. 350–61.

13 See P. Galassi, *Corot in Italy*, New Haven and London 1991, pp. 123–28. For the importance of Olevano and Civitella see *In the Light of Italy. Corot and Early Open-Air Painting*, exhib. cat. edd. P. Conisbee *et al.*, National Gallery of Art, Washington *et al.*, 1996 and *Deutsche romantische Künstler des frühen 19. Jahrhunderts in Olevano Romano*, exhib. cat. edd. H. Börsch-Supan *et al.*, Villa De Pisa, Olevano Romano, 1997.

14 N. Wright (ed.), *The Correspondence of Washington Allston*, Lexington, Kentucky, 1993, pp. 40–46.

15 See Galassi, *op. cit.*, and *Oil Sketches from Nature*, exhib. cat. by D.B. Brown, London, Tate Gallery, 1991.

16 Murray 1980, p. 139.

17 Collins 1848, I, pp. 181–82.

18 *Ibid.*, p. 110.

19 *Travels in Italy 1776–1783. Based on the Memoirs of Thomas Jones*, exhib. cat. by F.W. Hawcroft, Manchester, Whitworth Art Gallery, 1988, pp. 89–92.

20 Robertson 1978, pp. 11–19.

21 Noon 1991, pp. 47–48, 60.

22 Shapiro 1972, p. 46.

23 William Hazlitt, 'The Dulwich Gallery', *The London Magazine*, January 1823.

24 J. Gage (ed.), *Collected Correspondence of J.M.W. Turner*, Oxford 1980, p. 119.

25 Collins 1848, II, pp. 115–16.

26 Lister 1974, I, p. 155.

27 *Don Juan*, London 1819–24, I, lxiii.

28 Haskell and Penny 1981, pp. 316–18.

29 Collins 1848, II, p. 121.

Pictures from Italy

With peace in Europe and prosperity in Britain, Continental tours were no longer the privilege of wealthy aristocrats: many educated middle-class families, such as Ruskin and his parents, started making them regularly. These tourists required new and up-to-date guidebooks to Italy, but they also devoured Italy-related prose and poetry, pictures and illustrations. Very soon there was a massive upsurge in books on Italy, fuelled partly by renewed travel, partly by revolutionary developments in the techniques of book illustration. The views in the earliest book discussed below, Hakewill's *Picturesque Tour of Italy* (cat. 54), were engraved on copper plates which produce only a few hundred impressions before their finely incised lines become coarse and indistinct. From 1822, however, engraving on copper was largely replaced by engraving on a much harder material, steel. This can be used to print many thousands of impressions of engravings with the most minutely differentiated gradations of tone; indeed, without the use of steel plates, the complex light effects which enchant the viewer's eye in Turner's tiny vignettes of the 1830s would have been impossible for a long and profitable print-run (cats. 59–62, 64). The same period also saw the invention of a totally different process, lithography, which produces illustrations of a very distinct atmosphere and subtlety, evoking the softness of a pencil drawing (cat. 72, not illus.). Lithography, as its name implies, involves drawing on stone rather than metal and a chemical process rather than one of incised lines; it was employed to superb effect by two masterly draughtsmen who also had successful careers as drawing masters, Prout and Lear.

Thanks to these new markets and new printing techniques, pictures from Italy started appearing in many different types of book. While guidebooks might carry a frontispiece or a handful of illustrations, as in the past, there was now a vogue for illustrated books

Facing page Detail of cat. 30

intended for pleasure in the home rather than help on the tour. Aristocrats, of course, had long enjoyed such volumes; few gentlemen's libraries in eighteenth-century Britain were without a volume or two of Piranesi's magnificent etchings of Rome, published in the 1740s and 1750s, which shaped British ideas of the city and its architecture for several generations (fig. 6 on p. 23). In the 1790s John 'Warwick' Smith, one of the British landscape artists patronized by Grand Tourists, produced a handsome compendium, *Select Views in Italy*, which Turner studied keenly before his own first visit to Italy in 1819, making thumb-nail copies of all its scenes.[1] The successors to these books, aimed at a wider market, also had illustrations as their main ingredient; the text was merely a series of extended captions based on quotations from guidebooks or famous authors. These books were published by subscription, as part-works, with a small group of engravings appearing every few months over a couple of years. The middle classes enjoyed collecting the parts, thus paying for the book by instalments. They also bought volumes of poetry and narratives of tours by other travellers, both now frequently illustrated.

Like their grander predecessors, they composed or transcribed their own tour journals in large bound volumes for private circulation among family and friends, often including not only souvenirs such as topographical prints but also sketches and watercolours by members of the family; drawing was part of the education of every young lady and, indeed, of many young men. The creation of such volumes, by copying out diaries and working up careful watercolours from quick on-the-spot sketches, was often the work of years (see cat. 67 on p. 99). Although Thomas and Anne Mills visited Italy in 1820, the journal illustrated with her watercolours was not created until the late 1820s and may even have been made by Thomas alone, after Anne's death in 1827, as a comfort and memorial.

Travel also became an important ingredient in a new

type of small illustrated book which was introduced into England in 1823 by the German émigré publisher Rudolph Ackermann and remained popular through to the end of the 1850s. This was the 'annual', a Christmas and New Year anthology of prose and poetry embellished with pretty scenes, published in the late autumn and chiefly intended as a gift for the ladies. In the early 1830s, when the vogue was at its height, purchasers had over sixty titles from rival publishers to choose between. Some, like *The Keepsake* (cat. 55), provided a diversity of subjects, writers and artists in each volume so as to entertain readers through the winter in their boudoirs. Others, including *The Landscape Annual* (cat. 56) and *Heath's Picturesque Annual* (cat. 57), took a particular topographical theme, presenting it through the words of just one writer and the drawings of a single artist; such annuals had a lasting value and interest for armchair travellers of either sex. Writers and artists frequently mocked the annuals amongst themselves as trivial and worthless, but they were so widely disseminated among persons of means and taste that in practice few

54 J. Middiman and John Pye after J.M.W. Turner
La Riccia, in James Hakewill, *A Picturesque Tour of Italy* (1818–20)
Line engraving on copper, 14.3 × 22 cm (5⅝ × 8⅝")
Cecilia Powell

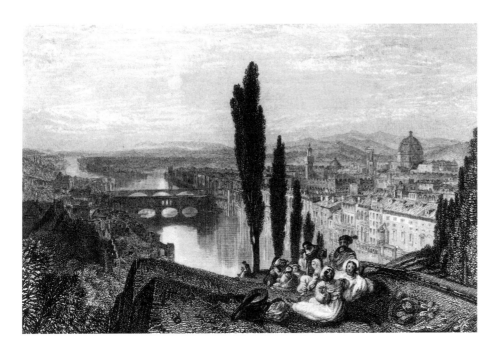

55 EDWARD GOODALL AFTER J.M.W. TURNER
Florence, in *The Keepsake for 1828*
Line engraving on steel, 8.8 × 13 cm ($3^{7}/_{16} × 5^{1}/_{8}''$)
Cecilia Powell

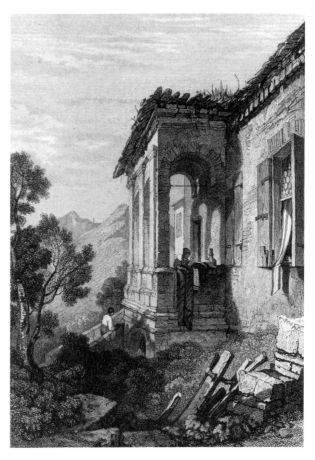

56 CHARLES HEATH AFTER SAMUEL PROUT
Petrarch's House at Arquà, in *The Landscape Annual for 1830*
Line engraving on steel, 14.1 × 9.8 cm ($5^{1}/_{2} × 3^{7}/_{8}''$)
Jan Piggott

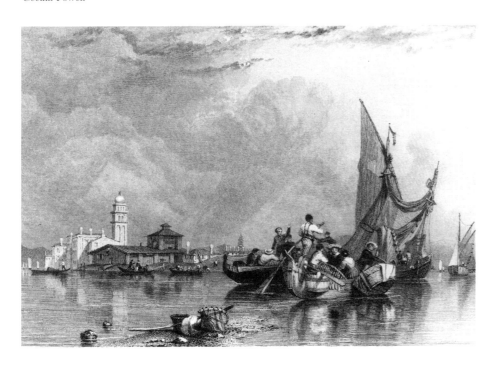

57 ROBERT WALLIS AFTER CLARKSON STANFIELD
Murano, in *Heath's Picturesque Annual for 1832*
Line engraving on steel, 9.8 × 14.3 cm ($3^{7}/_{8} × 5^{3}/_{4}''$)
Jan Piggott

could resist the commercial opportunity of contributing to them whenever they could.

Artists welcomed commissions for illustrations of Italy, ever a popular subject with potential for fame and profit. Once Prout reached his forties, his annual income averaged some £650–700, of which about half was derived from the fees from his many topographical book illustrations. When he was paid £360 in 1830 for his twenty-six Italian scenes for the second of the *Landscape Annuals*, his income reached £1000.[2] On their hardworking Italian honeymoon of 1837–39 the Palmers discovered how desperately difficult it was to obtain commissions for watercolours; Hannah conceived the idea of herself making a set of etchings from Samuel's Italian scenes and selling them to Colnaghi's who would then publish and publicize them, creating a reputation and a small fortune for the artist.[3] Sad to say, this idea remained a daydream. When Samuel did receive a commission for some Italian illustrations, through Colnaghi's, the remuneration for his hours of painstaking work was pathetically small: for the set of four small scenes, drawn directly on to wooden blocks, which appeared as engravings in Dickens's *Pictures from Italy* (1846; cat. 71), Palmer received just 20 guineas.[4] By contrast, Turner commanded up to 30 guineas from John Murray for each of his watercolours to Byron (cat. 64).[5] When Turner died in 1851, surrounded by his many unsold and unsaleable oil paintings, he was found to have a fortune of nearly £140,000, which was largely the fruits of a lifetime of work for engravers. Artists pinned great hopes on possible commissions and inevitably feelings ran high when these were disappointed. Virtually every publication featured in this exhibition involved rivalry, disappointment, argument, controversy, plagiarism or intrigue before their exquisite illustrations reached their audience. In short, their histories mirrored the glory and pathos of Italy itself.

The planning of James Hakewill's *Picturesque Tour of Italy* (a part-work, published between 1818 and 1820)

was the occasion of a massive row between its author and publisher. Having travelled in Italy in 1816–17 and amassed over 300 pencil sketches, the architect Hakewill wanted to produce a really grand book with no less than eight different well known artists (including Turner) working up sixty of his sketches in watercolours which would then be handed over to an even larger team of top engravers. John Murray disagreed, insisting on a book about half the size with Turner as its sole named artist. His prudence was well founded, for the book was not a commercial success, despite Turner's scenes (cat. 54), which were widely admired. A decade later, another publisher pirated several of them to illustrate a small pocket guidebook which consisted chiefly of plagiarized and unattributed material, Josiah Conder's *Italy* (1831).[6]

When Uwins left England in 1824, he intended to execute a series of views of Venice for publication but he had scarcely crossed the Alps when he heard that Prout was there for the very same purpose. Realising he could not compete in this field against such a well known figure as Prout (not to mention his publisher Ackermann), he philosophically abandoned all thoughts of his project and made other plans. It was later suggested to him that he might like to collaborate by supplying the text to accompany Prout's scenes, but his painterly pride and ambition prevented him from accepting what he regarded as a menial and time-wasting task.[7] In the end, sadly, the Prout–Ackermann volume of Venetian lithographs never materialized. A few years later, Prout himself was upstaged over another Italian project and took it extremely badly. Having illustrated the first two *Landscape Annuals* on Italy, he had expected to do the third one, but this commission was given to his former pupil, friend and rival, J.D. Harding. Prout was bitterly hurt that Harding should have accepted the assignment and their friendship never recovered.[8]

Turner experienced several disappointments around this time, chiefly due to the financial troubles of some of his publishers, but they were far outweighed by some

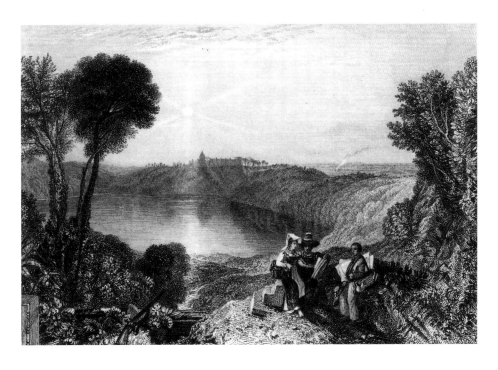

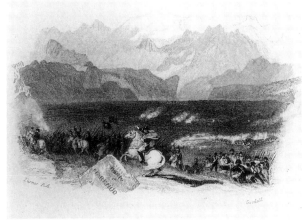

outstanding successes. The three little Italian scenes which appeared in one of the better class of annuals, *The Keepsake*, in the late 1820s – *Florence* (cat. 55), *Lake Albano* (cat. 58, accompanied by a short story by Mary Shelley) and *Lake Maggiore* (with verses by Robert Southey) – were based on large, complex watercolours painted for a much more substantial work, *Picturesque Views in Italy*. Had this not been abandoned soon after its conception, it would have matched his famous *Picturesque Views in England and Wales*. The three volumes of *Turner's Annual Tour* devoted to the Loire and the Seine in the early 1830s turned out to be the only three in this series; the publisher's advertised aim that Turner would cover other great European rivers in similar fashion (presumably including some of those in Italy) was never realised. Just at this juncture, however, the illustration of poetry and prose displaced topography in Turner's work for the engravers. In this field, too, competition and rivalry were intense, sometimes resulting in unexpected benefits to artists.

The 1830 edition of Samuel Rogers's *Italy*, with landscapes after Turner, was the most successful, important and influential illustrated book on Italy in early nineteenth-century England (cats. 59–61). Together with its companion volume of Rogers's *Poems*, published in 1834 in identical format (cat. 62), it sold over 50,000 copies before 1847.[9] Frederick Goodall, the son of one of Turner's engravers, later remarked that there was scarcely an educated household in the country that did not have a copy of *Italy*.[10] Ruskin received one on his thirteenth birthday in February 1832, as a gift from his father's business partner, and few gifts can have shaped the career of an individual and ultimately influenced the cultural history of a nation so dramatically. The hours the boy spent poring over Turner's magical scenes filled him with such wonder and delight that he became, then and there, Turner's champion against all his critics, a crusade which he fought till the end of his life.

Rogers's *Italy* had not been particularly successful when it was first published in the early 1820s, although

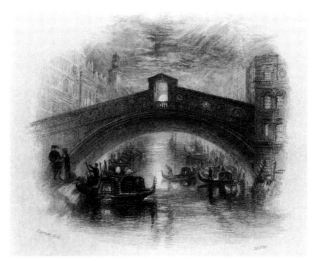

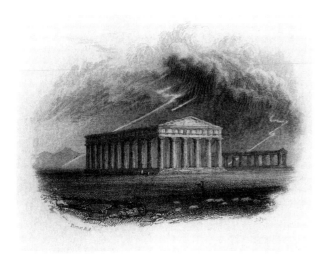

60 EDWARD GOODALL AFTER J.M.W. TURNER
Florence, in Samuel Rogers, *Italy* (1830)
Line engraving on steel, vignette, 5.8 × 8.8 cm (2¹/₄ × 3¹/₂″)
Private collection

61 JOHN PYE AFTER J.M.W. TURNER
Paestum, in Samuel Rogers, *Italy* (1830)
Line engraving on steel, vignette, 6.4 × 8.7 cm (2³/₈ × 3³/₈″)
Private collection

the poet had enjoyed a high reputation since the 1790s. In 1814–15 he was one of the Britons who contrived to visit the Continent between Napoleon's abdication and his final defeat at Waterloo, and soon afterwards he started to prepare a collection of short poems crystallizing the experiences vividly recorded in his Italian journal. In April 1818, however, his dreams were shattered by Canto IV of Byron's semi-autobiographical epic, *Childe Harold's Pilgrimage.* Byron had travelled in northern and central Italy in 1816–17 and he now evoked Venice, Rome and the ruin-strewn countryside of Italy so brilliantly that his lines were on everyone's lips and in every traveller's pocket. When *Italy* appeared a few years later (anonymously, so as to escape accusations of personal rivalry) the public had already drunk its fill of a far more potent vintage than Rogers could ever supply.

However, Rogers had one advantage over Byron: he belonged to a wealthy banking family (indeed, his own art collection included works by Raphael, Titian and other Renaissance masters). Soon after Byron's death in 1824, Rogers set about publishing a new edition of *Italy* at his own expense. He commissioned twenty-five landscapes from Turner and nineteen scenes from Stothard,

a long-established illustrator of literature and famous for his graceful figures. He employed a team of thirteen engravers. He designed the book so that readers could have the rare luxury of savouring both words and steel-engraved vignettes on the same page; this was fiendishly expensive since each illustrated page needed two separate printing processes and had to pass through the press twice. By such means, and by laying out £7335 in publishing just 10,000 copies, Rogers ensured both the instant success and the widespread fame of his *Italy*. As the century continued, its verses survived in their own right, often being quoted in guidebooks and elsewhere and reprinted in illustrated and unillustrated editions in which Turner played no part.[11] The illustrations in some of these vary from the unexpected to the droll; one edition (see cat. 63) includes spiky little sketches by Callcott, better known for his smooth and luminous

canvases, and a cat's supper scene by Landseer, Britain's premier painter of dogs.

Meanwhile Turner and several others (including Prout, Harding, Callcott and Stanfield) were busy with illustrations to Byron, not just to Canto IV of *Childe Harold* but for a comprehensive, seventeen-volume edition of *The Life and Works* of the poet which John Murray issued in 1832–34. Each volume carried two illustrations – a frontispiece (cat. 64) and a title-page scene – and Turner contributed exactly half the total, distributed throughout the volumes and depicting a variety of scenery and countries. He contributed simultaneously to what was in effect a 'Byron Companion', *Finden's Landscape Illustrations to ... the Life and Works of Lord Byron*, a lavish publication in three large volumes with many contributors; here again his quota included Italy among its subjects. These publications formed part of the new obsession with Byron that swept the country after his death. Sometimes this mania bordered on the ridiculous: Finden's work included Italian views with captions admitting that Byron never visited the places and never wrote about them either. Despite this tendency to overkill, many good painters and illustrators were genuinely inspired by the profounder passages in Byron's verses, particularly the Italian sections of *Childe Harold* (cat. 65). There was also a sudden proliferation of these subjects at public art exhibitions. Among them Turner's own painting of 1832 is outstanding as an epitome of the Italy, past and present, through which the poet and his hero had made their melancholy pilgrimage (cat. 50 on p. 84).[12]

Byron's Italian verses were, of course, a godsend to writers and editors. Hakewill managed to insert some of those on the Cascade at Terni into Part IV of his *Picturesque Tour* in January 1819, less than a year after they appeared, achieving the distinction of presenting the first published conjunction of a Turner image and a Byron quotation. *The Landscape Annual for 1830* quoted abundantly from both Rogers and Byron, reminding

234

And now—along the corridor it comes—
I cannot err, a filling as of baths !
—Ah, no, 'tis but a mockery of the sense,
Idle and vain ! We are but where we were ;
Still wandering in a City of the Dead !

THE BAG OF GOLD.

I DINE very often with the good old Cardinal * * and, I should add, with his cats ; for they always sit at his table, and are much the gravest of the company. His beaming countenance makes us forget his age ; † nor did I ever see it clouded till yesterday, when, as

† In a time of revolution he could not escape unhurt ; but to the last he preserved his gaiety of mind through every change of fortune ; living right hospitably when he had the means to do so, and, when he could not entertain, dining as he is here represented—*en famille.*

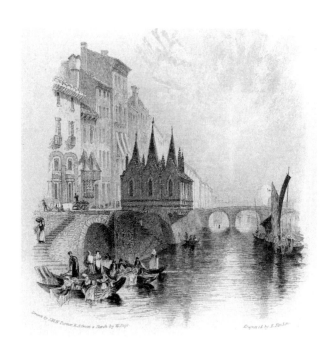

64 EDWARD FINDEN AFTER J.M.W. TURNER
Santa Maria della Spina, Pisa, in *The Life and Works of Lord Byron* (1833–34), vol. 5
Line engraving on steel, vignette, 8.8 × 8.4 cm (3³/₈ × 3¹/₈″)
Cecilia Powell

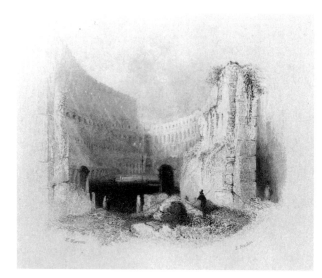

65 EDWARD FINDEN
AFTER HENRY
WARREN
Rome. Interior of the Coliseum,
in Lord Byron, *Childe
Harold's Pilgrimage* (1845 edn)
Line engraving on steel,
vignette, 7 × 8.5 cm
(2³/₄ × 3¹/₄″)
Jan Piggott

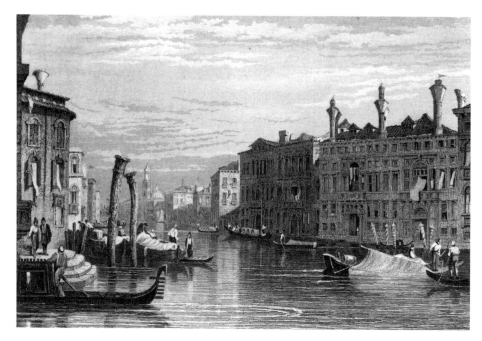

66 ROBERT WALLIS AFTER SAMUEL PROUT
Mocenigo Palace, Venice, the residence of Lord Byron, in *The Landscape Annual for 1831*
Line engraving on steel, 9.4 × 14.1 cm (3⁵/₈ × 5⁵/₈″)
Jan Piggott

readers not only of *Childe Harold* but also of *The Two Foscari*, Byron's drama of 1821 based on a famous tragic episode from Venetian history. *The Landscape Annual for 1831* went even further when it included 'Byron's Palace' among the principal sights of Venice (cat. 66). The poet who had been "mad, bad and dangerous to know" was now safely part of history, and his Venetian hide-away was a tourist attraction every bit as potent as Titian's house in Venice or that of Petrarch in Arquà (cat. 56).

For many years after Byron's travels in Europe it was possible for other British visitors to encounter those who had met him or served him – or at any rate claimed to have done so. This was the case with the Revd Thomas Mills and his wife Anne, who made a tour of the

67 ANNE MILLS
Contadine near Bozzolo, in
Thomas Mills, 'Journal of a
Tour made in 1820', after
1826 (text transcribed on
paper watermarked 1819,
drawings mounted on paper
watermarked 1826)
Watercolour, 21 × 15.3 cm
(8¼ × 6″)
Private collection

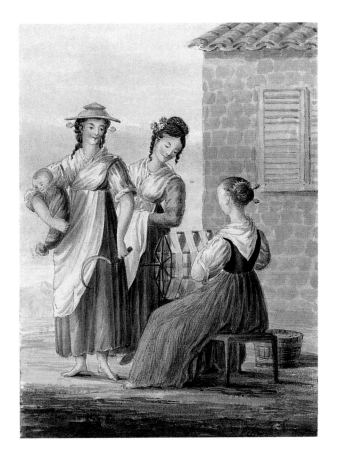

Continent in 1820. They were taken out on the Lake of Geneva by a boatman who had performed the same service for Byron a few years earlier and now regaled them with an account of the poet's nocturnal excursions on the lake, silent except for his discharging of firearms.

Most tourists followed well trodden paths through Italy and their journals echoed familiar facts and conventional opinions, repeated for decades from one guidebook to another even when conspicuously laden with errors. Mills's journal is notable for its frequent comments on recent events and the condition of post-Napoleonic Europe, but the young couple (who had left an infant in England) did not venture off the beaten track. Like thousands of others, they visited famous churches and galleries, admired beauty spots, attended

the opera, bought souvenirs and conversed with fellow-tourists. Thomas recorded unfamiliar Catholic practices in great detail, while Anne was equally fascinated by women's costumes, occupations and customs such as the swaddling of babies (cat. 67). The only real difficulties they had to face were flea-infested bedclothes, thefts of money and clothes from their luggage, and being caught in a violent storm on Lake Maggiore.

The Revd Thomas Mills has a special connection with Dulwich and this exhibition. In 1796 his father, Thomas Mills of Saxham Hall, near Bury St Edmunds in Suffolk, bought and presented to Dulwich College a copy of one of Italy's most celebrated paintings: a fine, almost full-size, replica (then thought to be by Giulio Romano) of Raphael's *Transfiguration* (fig. 33). In 1797, Raphael's original was among the many works to be seized from Italian churches and palaces by Napoleon to be put on display in his own art museum in Paris; there it remained until its restitution in 1815. *The Transfiguration* was Raphael's last great work, left unfinished at his early death in 1520 and movingly described in Vasari's *Lives of the Artists* later that century: this tells of the heart-breaking sight of the young painter's dead body lying beneath his final masterpiece with its crowd of living, breathing forms culminating in the figure of Christ, in which mortal and divine are eternally fused. Vasari's account inspired verses by Rogers as the finale of his poem 'A Funeral', which was accompanied in the 1830 edition by an equally tender illustration by Stothard (cat. 68).

Other Britons, like Eastlake and the Grahams in 1819 and Lear in the 1840s, were far more adventurous in their aims than Mills and his wife, if not actually reckless, and this enabled them to present narratives and illustrations of startling novelty. Eastlake and the Grahams retreated from the scorching Roman summer to the cooler air of the adjacent hills, travelling no great distance but venturing into an area notorious for its brigandage. Eastlake's earliest bandit scenes, his

68 JOHN HENRY
ROBINSON AFTER
THOMAS STOTHARD
The funeral, in Samuel
Rogers, *Italy* (1830)
Line engraving on steel,
vignette, 6.5 × 9 cm
(2½ × 3½″)
Jan Piggott

illustrations to Maria Graham's revelatory *Three Months passed in the Mountains East of Rome* (cats. 69–70), were produced by aquatint. This well established medium, with its capacity for the depiction of contrasting areas of light and shadow, was well suited to the romantic and mysterious nature of his subjects, not to mention the shady activities of many of their characters.

Two decades later Lear went much further afield: he explored a host of minor towns in the papal states and made three tours of the Abruzzi, the little known and least frequented area of central Italy, extending from the countryside north of Rome across to the Adriatic coast. He presented both regions to the public in his *Views in Rome and its Environs* (1841; cat. 72, not illus.) and the two volumes of his *Illustrated Excursions in Italy* (1846), laying special emphasis on the originality of his Abruzzi journeys and the uniqueness of their illustrations. These were produced by lithography and were all based on his own recent on-the-spot sketches, apart from three cos-

FIG. 33 ITALIAN ARTIST OF THE SIXTEENTH
CENTURY AFTER RAPHAEL
The Transfiguration
Oil on canvas, 376.6 × 264.8 cm (148¼ × 104¼″)
Dulwich Picture Gallery

tume drawings provided by his friend Penry Williams.

Besides Lear's *Illustrated Excursions*, the year 1846 also saw the appearance of Dickens's *Pictures from Italy*. This was not a straightforward tour narrative but a series of literary sketches stimulated by the writer's residence there, chiefly in Genoa. Dickens went to Italy in 1844, accompanied by an enormous family party which included children, nursemaids and even the family dog, after a farewell dinner at Greenwich attended by

69 J. Clark after C.L.
Eastlake
Peasants in search of banditti, in Maria
Graham, *Three Months passed in the
Mountains East of Rome, during the Year
1819* (1820)
Aquatint, 10.2 × 16.2 cm (4 × 6³⁄₈″)
Cecilia Powell

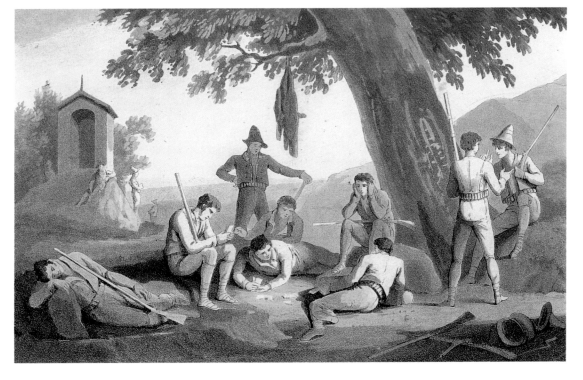

70 J. Clark after C.L.
Eastlake
Station of the brigands near Guadagnola, in
Maria Graham, *Three Months passed in
the Mountains East of Rome, during the Year
1819* (1821 edn)
Aquatint, 10.2 × 16.2 cm (4 × 6³⁄₈″)
Cecilia Powell

Stanfield and Turner. The travellers remained abroad for almost a year, Dickens being determined to write about Italy, following the example of Fielding and Smollett, Goldsmith and Hazlitt. His account was published soon after his return, initially in *The Daily News* from January to March 1846 and in book form the same year. Just as travel itself was now much faster and easier than at the beginning of the century, thanks to the advent of steamboats and the railway, so, too, the instalments of Dickens's travelling sketches reached their destination in people's homes more swiftly, regularly and frequently than the instalments of earlier works on Italy such as Hakewill's *Picturesque Tour* or *The Landscape Annuals*.

Dickens's glimpses of Italian life are always perceptive, by turns humorous, hostile and devastatingly critical. As with his other books, he intended that this should be illustrated by an eminent British artist. The person first chosen was Stanfield, a close friend who had already travelled widely in Italy and often depicted it in paintings and watercolours (cat. 23, p. 43). However, Stanfield was a Roman Catholic and, having read Dickens's blistering comments on Catholic practices in Rome and Naples, he excused himself from the task. A substitute was found in Samuel Palmer, who embellished the book with four landscape scenes of famous or typical sights, filled with a gentle pastoral nostalgia (cat. 71).[13] Their style, too, looks back to the past, for they are evocative of the wood-engraved vignettes of a much earlier period, including those of the original editions of Rogers's *Italy* which they deliberately sought to emulate. Palmer's tranquil, leafy scenes give no hint of the fire raging behind Dickens's words, but they were certainly the pictures from Italy that lingered most pleasantly in every traveller's mind.

They were not, however, the key to the future. That role belonged to very different pictures: the engravings of the frescos in the Campo Santo at Pisa by its curator, Carlo Lasinio, and the drawings of British architects and of Ruskin (accompanied, of course, by his thundering prose). In emulation of the earliest Italian painters, the young artists of the Pre-Raphaelite Brotherhood were soon engrossed in casting off the fetters of their teachers and pursuing simplicity and exact fidelity to the nature before their eyes. Architects enriched towns and cities all over Britain with buildings inspired by the Renaissance palaces of Florence and Venice and with polychrome churches in imitation of Italian Gothic with its spiritual heritage. Ruskin and others came to recognize, reluctantly and sometimes painfully, that the greatest Christian art had been created by artists and craftsmen who were Roman Catholics. Britons carried on looking intently at modern Italy but they also studied more and more aspects of its past with ever-increasing zeal.

NOTES

1 Powell 1987, p. 14.

2 Lockett 1985, pp. 67–68.

3 Lister 1974, I, p. 179.

4 E.W.F. Tomlin, *Charles Dickens 1812–1870*, London 1969, pp. 219–21.

5 Brown 1992, pp. 106–18.

6 Powell 1987, pp. 14–18.

7 Uwins 1858, I, p. 387; II, pp. 12, 27–28.

8 Lockett 1985, pp. 79–80.

9 H. Curwen, *A History of Booksellers*, London 1873, pp. 352–53.

10 Piggott 1993, p. 35.

11 Powell 1987, pp. 131–36; Piggott 1993, pp. 35–39.

12 Powell 1987, pp. 187–88; Brown 1992; Piggott 1993, pp. 44–49.

13 Charles Dickens, *Pictures from Italy*, ed. D. Paroissien, London 1973, pp. 247–49.

71 SAMUEL PALMER
The vintage, in Charles Dickens, *Pictures from Italy* (1846)
Engraving on wood, vignette, 13.3 × 7.4 cm (5¼ × 2⅞″)
Cecilia Powell

And let us not remember Italy the less regardfully, because, in every fragment of her fallen Temples, and every stone of her deserted palaces and prisons, she helps to inculcate the lesson that the wheel of Time is rolling for an end, and that the world is, in all great essentials, better, gentler, more forbearing, and more hopeful, as it rolls!

THE END.

London: Bradbury & Evans, Printers, Whitefriars.

The Artists and Italy

RICHARD PARKES BONINGTON
(1802–1828)
See cats. 42, 44; fig. 30

Bonington was born near Nottingham but his family moved to France in 1817, when he himself was just fifteen. He received much of his art training at the Ecole des Beaux-Arts in Paris with Baron Gros but he also came under strong English influences: he initially studied in Calais with F.L.T. Francia, previously an associate of the leading London watercolourists, and he visited London in 1825, 1827 and 1828 and exhibited his works there. In 1826 Bonington accompanied his friend and patron Baron Charles Rivet on an eleven-week tour of Italy, leaving Paris on 4 April. Later that month they made short sojourns at Milan, Lake Garda, Brescia and Verona, culminating in nearly a month in Venice. Here, after incessant rain and overcast leaden skies, the weather suddenly cleared and Bonington was enthralled by the beauty of the city. On 19 May they left Venice (Bonington with great reluctance), travelling down through Padua and Ferrara to Florence and Pisa, their furthest south, whence they headed north to Sarzana, Lerici, La Spezia, Genoa, Alessandria and Turin. Returning through Switzerland, they arrived back in Paris on 20 June. This was to prove Bonington's only visit to Italy, as he died in London two years later.

Bonington's works were greatly admired by his contemporaries in both France and England: the lively, luminous style of his watercolours, uniting thin washes with confident and accurate drawing, was soon imitated by other Britons, including Lewis, Harding and Stanfield, while the brilliance and fluidity of his oils brought a breath of fresh air into the stuffy studios of Paris. Under the inspiration of Titian, Veronese and their contemporaries, he created many small, warmly coloured paintings of figures in historical costume in Italian settings. His commercial success in England with Venetian views inspired many other British painters to essay this genre, the most notable example being Turner.

Detail of fig. 14

AUGUSTUS WALL CALLCOTT (1779–1844)
See cat. 63; fig. 26

Callcott visited Italy in 1827–28, soon after his marriage to Maria Graham (see below). It was one of the longest, most intensive and varied visits by a British painter who did not actually take up residence there and was recorded in some detail in Maria's journal. After travelling through Germany and Austria they reached Venice in mid October. Over the next few months they travelled down Italy as far as Paestum, lingering for two or three weeks in major cities such as Venice (October), Florence (December) and Rome (January and March) and also spending entire days exploring lesser towns and studying their art treasures. They constantly made notes and sketches; they bought books, paintings and prints; they visited studios, dealers, academies and workshops; they were in touch with many British and foreign artists, including Eastlake, Severn, Penry Williams and Uwins. They also enjoyed other social contacts wherever they went. In Rome these included the historian Henry Hallam and his teenage son, Arthur, whose death in 1833 was to inspire Tennyson's 'In Memoriam'. In Pisa the Callcotts were shown the Campo Santo by the curator Carlo Lasinio, whose engravings of its early frescos were to have such an important influence on the English Pre-Raphaelites. In Florence they looked through the early Italian drawings in the Uffizi with its director Ramirez di Montalvi.

Callcott's own paintings of Italy are typically topographical works – luminous lake or river scenes and broad landscapes, reflecting his association with Turner which had been especially strong at a personal level in the 1820s. By complete contrast, in 1837 he exhibited an imaginary scene showing Raphael with his mistress, the Fornarina; this large and detailed historicizing work was a fitting culmination to Callcott's studies in Italy and his contacts with the Nazarene painters in Germany.

WILLIAM COLLINS (1788–1847)
See cat. 26

William Collins made his only visit to Italy in his late forties, having been strongly encouraged to go there years earlier by his close friend the painter David Wilkie. Intending to be away an entire year, he left England in September 1836 with his wife and family – including his two young sons. William Wilkie Collins, born in 1824, was named after his godfather and later became famous as the novelist Wilkie Collins. Charles Allston Collins, born in 1828, was also named after his godfather (the American painter Washington Allston); he subsequently became a painter and an associate of the Pre-Raphaelites, being especially close to Millais.

The family travelled overland through France and then by steamer from Genoa to Livorno. They spent Christmas and New Year in Florence and then immediately made for Rome where they remained until Easter. After this they spent many months in the south: an outbreak of cholera in Naples forced them to take refuge in Sorrento but soon afterwards Collins became so ill through working in the sun that he had to spend nearly a month at the sulphur baths on Ischia to regain his strength. The family returned to the Naples area in November and to Rome the following February, where they remained to see the spectacles of Holy Week and Easter a second time before heading for home at the end of April. They paid a second visit to Florence and spent a whole month in Venice before finally leaving Italy at the end of June 1838.

Collins was a neighbour of Hannah Palmer's father, John Linnell, in Bayswater and the Collinses' time in Italy overlapped with that of the Palmers, with whom they had some contact in Rome.

WILLIAM COWEN (1797–1861)
See cat. 3

A native of Rotherham in Yorkshire, Cowen travelled to Switzerland and Italy at the expense of his patron, Earl Fitzwilliam, the owner of Wentworth Woodhouse. Once there, he made many landscape sketches which he later used as the basis for paintings. He was already in Italy at the time of the 6th Duke of Devonshire's visit in the first half of 1819, but had probably been introduced to him the previous year. In 1828 he was invited to work for the Duke at Chatsworth, which he depicted in two watercolours. In 1824 he published *Six Views of Italian and Swiss Scenery* and he also contributed scenes to William Brockedon's *Italy, Historical, Classical and Picturesque* (1842–43). In 1840 he went to Corsica, later publishing etchings of its scenery and an account of his tour.

THOMAS HARTLEY CROMEK (1809–1873)
See fig. 12

Cromek was the son of the engraver and publisher Robert Hartley Cromek (1770–1812), who was a pupil of Francesco Bartolozzi and is remembered today largely for his differences with William Blake and for commissioning Thomas Stothard to paint *The Canterbury Pilgrims*. Thomas Cromek first visited Italy in 1830–32, where he soon acquired patrons thanks to letters of introduction from the Cheney family. Especially useful was the contact with the collector and antiquarian Edward Cheney (1803–1894), then resident in Rome, who was later to extend invaluable help to Sir Walter Scott in Rome (1832) and Ruskin and his wife in Venice (1851–52). Cromek spent much of the 1830s and 1840s on the Continent, chiefly in Italy but also visiting Greece in 1834 and 1845. Most of his time in Italy was spent in Rome but he also visited Venice, Florence and its environs, Assisi and Subiaco. He made extremely detailed watercolours for the tourist market, usually close-up studies of Roman ruins. These were also engraved and published in works such as W.B. Cooke's *Rome and its Surrounding Scenery* (1840).

JOHN SCARLETT DAVIS (1804–1845)
See cat.29

Davis was born in Leominster and came to London in 1818. From the late 1820s he specialized in painting interiors, especially those of galleries and houses rich in works of art. He visited Italy in 1833–34, spending many months painting and drawing in Florence; some of these scenes, including a view in the Uffizi, were etched in his *Views of Florence and Other Parts of Italy* (begun in 1833). He spent several months in the cities of northern Italy in 1838, 1839 and 1840 and again recorded gallery interiors, densely hung with paintings. These views reached their natural culmination when he painted the grandest and richest interior in all Italy in the 1840s. In 1841 he travelled to Rome to fulfil a commission from his principal patron, John Hinxman, for a vast view of St Peter's. This painting (measuring almost ten feet across) required many months of work and preparatory studies, including cat. 29. Davis remained in Rome until the spring of 1842 and continued to work on the painting back in London, exhibiting it early in 1844. Already ill with chest problems at this time, he died the following year.

CHARLES LOCK EASTLAKE (1793–1865)
See cats. 19, 24, 69–70; figs. 7, 28

Eastlake was among the earliest British artists to visit Italy after the end of the Napoleonic Wars, leaving England in September 1816 and arriving in Rome two months later. He remained in Italy, living mostly in Rome, until 1830, breaking his stay only to make a long tour of Greece in 1818 (with Charles Barry and others) and to visit England briefly in 1820–21 and 1828. Like Cowen, Eastlake was patronized in Rome by the 6th Duke of Devonshire, for whom he painted a huge history picture, *The Spartan Isadas*, in 1826. Thanks to the

success of this picture when it was exhibited in London the following spring, Eastlake was elected an Associate of the Royal Academy in November 1827, despite being resident abroad; he was the first artist ever to be elected *in absentia*. Chiefly concerned with figure subjects, he devoted close attention in Italy to the art of both past and present, and his own paintings show a similar breadth of interest, ranging from historical and poetical scenes (sometimes with contemporary political references) through to stories from everyday life.

He returned to England in 1830, after being elected a full Royal Academician, but continued to paint repetitions of his most popular Italian scenes. He was President of the Royal Academy from 1850 to 1865. Having held the post of Keeper of the National Gallery from 1843 to 1847, he became its first Director when this office was constituted in 1855 and was instrumental in acquiring many important early Italian paintings for the collection until his death.

WILLIAM ETTY (1787–1849)
See cat. 6

Etty left England for Italy even earlier than Eastlake, setting out in August 1816 with the idea of spending a whole year there, studying the Old Masters and the sculptures of antiquity. As it turned out, he reached no further than Florence. By 5 October, after a bare month in Italy, he was so discouraged by the difficulties of travel and so paralysed by his own fear of bandits and sickness that he abandoned his plans; he was back in Paris before the month was out. He fared much better on his second attempt a few years later, thanks to the companionship of his friend Richard Evans, a painter already familiar with Italy. On this occasion Etty threw himself wholeheartedly into his Italian studies for well over a year (July 1822 – October 1823), to the indisputable benefit of his later paintings of historical subjects and the female nudes at which he excelled.

JOSEPH MICHAEL GANDY (1771–1843)
See cat. 18

In the late 1780s Gandy was a pupil of the architect James Wyatt (who had spent many years in Italy in the 1760s) and a prize-winning student at the Royal Academy Schools. He was sent to Rome in 1794 through the patronage of his father's employer, John Martindale, the proprietor of White's Club in St James's. In 1797 his visit was cut short by the news of Martindale's bankruptcy, closely followed by the French invasion of Italy, and he was back in England by June. The following year he became an assistant to John Soane but was frustrated in his aim to work as an architect. Soane employed him as draughtsman for many of his most imaginative and unrealizable projects and Gandy also made fantastic illustrations on his own account, including some for Dante's *Inferno*. His younger brother John Peter (1787–1850) succeeded as an architect, taking the name of Deering. It was he who provided the factual and topographical illustrations for the first volume of Sir William Gell's *Pompeiana* (1817–19), where he was named as co-author.

THOMAS GIRTIN (1775–1802)
See cat. 1

Girtin never visited Italy but had he lived longer he would certainly have done so. Like other British artists of his age, he made many drawings and watercolours after a variety of recent Italian masters including Piranesi, Marco Ricci and Canaletto. He copied classical compositions by the Frenchman Clérisseau and etchings by the Italianate Dutch artist Swanevelt. Girtin was born in Southwark and spent most of his short life in London. Between *ca.* 1794 and 1798 he and Turner often worked together in the evenings at the house of Dr Thomas Monro in the Adelphi, south of the Strand. One of their principal occupations was making watercolour copies after the nostalgic scenes of J.R.Cozens (1752–1797) who had visited Italy in 1776–79 and 1782–83

and was now a mental patient in Monro's care. Girtin's ability to create broad and atmospheric landscapes became manifest early in his career and in 1799 many connoisseurs thought that he had more genius than Turner, as the latter put too much finish and industry into his effects. However, he died of consumption at the age of twenty-seven, Turner famously remarking, "If Tom Girtin had lived, I should have starved."[1] We may add: if Girtin had gone to Italy, his health might have improved dramatically, like that of Lear and Uwins, and Turner's later career might indeed have been very different.

MARIA GRAHAM, later MARIA CALLCOTT (1785–1842)
See cats. 69–70

While sailing to Bombay in 1808–09 with her father, a rear-admiral in the British Navy, the twenty-three-year-old Maria Dundas met her first husband, Thomas Graham, also serving as a naval officer. After marriage and a period in India, the Grahams returned to Europe and in the autumn of 1818 they sailed for Sicily and Naples. In Malta they became acquainted with Eastlake and continued their friendship with him in Rome in 1819. They all shared a house, 12 Piazza Mignanelli, on the southern flank of the Spanish Steps, a stone's throw from that in which Keats was to die in 1821. Maria later declared that Eastlake was just like a brother to her and the three had lived together for sixteen months and never disagreed.

To avoid the heat of the Roman summer from June to September, they retreated to Poli, a village some twenty-five miles away, between Tivoli and Palestrina. Throughout her life Maria was an avid reader and a prolific writer of journals and books and she immediately set about composing *Three Months passed in the Mountains East of Rome*, published the following year. She must have been hard at work at it when she met Turner in the autumn of 1819; he later described her as "a very

agreeable Blue Stocking".[2] During her time in Italy she also made many sketches and watercolours.

After spending 1821–26 in Brazil and Chile, where her husband died in 1822, Maria returned to London. Within ten months she married the painter A.W. Callcott (see above), who took her on an extended Continental honeymoon, including sojourns in Venice, Rome, Naples and Florence. The journal she kept between May 1827 and June 1828 shows the same energy, concentration and curiosity about unfamiliar aspects of Italy as her writings of 1819–20, but her new husband pointed her in a new direction: the world of art dominated their thoughts and travels. They studied not only the work of established Old Masters but also that of much earlier and less well known painters such as Giotto, Mantegna and Piero della Francesca; they were concerned, too, with that of their European contemporaries working in Rome, most notably the German Nazarenes who were reviving the art of fresco painting. Maria's studies on her honeymoon bore fruit in two books. In 1835 she produced a slim folio monograph on the Arena Chapel at Padua, consisting of brief descriptions of the frescos, interspersed with a few very simple wood-engravings by her husband, showing the main figure groups. This was the first such book on the Arena Chapel to be issued, preceding the earliest Italian one by a year. It was followed by the two small volumes of her *Essays towards the History of Painting* (1836 and 1838).

EDWARD LEAR (1812–1888)
See cats. 15, 43, 45, 52, 72

A Londoner by birth and largely self-taught as an artist, Lear spent almost his entire working life abroad and Italy played a vital role in his career. Having suffered from epilepsy and been prone to asthma and bronchitis since childhood, he first visited Italy in 1837 thanks to the concern and assistance of his friend and patron the Earl of Derby. He remained there for the best part

of the next eleven years, based in Rome, after he discovered he could make an adequate living by giving drawing lessons to British tourists and residents and by producing landscape souvenirs for them. It was also the happiest period of his life. A shy and lonely man, he delighted in his contacts with other British artists. He was also inspired and moved by the isolated ruins of the Campagna, an emotion he was to recreate again and again with buildings in more distant countries. In the summer months he left Rome, usually with other painters; he travelled with James Uwins (nephew of Thomas) to Naples in June 1838 and lodged with Penry Williams and the Palmers in Civitella in July 1839. In 1842 he visited Sicily and also made a tour on horseback in the Abruzzi, partly with a friend from Rome, Charles Knight. Lear's first two books of lithographs – *Views in Rome and its Environs* (1841) and *Illustrated Excursions in Italy* (2 vols., 1846) – were the forerunners of further books of a similar nature on less familiar parts of the Mediterranean which he was to write, illustrate, see through press and sell by mail and subscription. The first volume of *Illustrated Excursions in Italy* brought Lear to the attention of Queen Victoria, who appointed him to give her a series of twelve drawing lessons at Osborne House in the summer of 1846. After many arduous tours in the Eastern Mediterranean, the Near and Middle East, India and Ceylon, Lear settled permanently in San Remo on the Italian Riviera, where he died.

JOHN FREDERICK LEWIS (1805–1876)
See cats. 4, 28

Italy was just one of the many destinations of this much travelled artist, a member of a family which was particularly distinguished for its topographical painters in the nineteenth century. He himself is as notable for his acutely observed figure studies as for his depictions of southern light and exotic architecture. On his first European tour in 1827 Lewis spent the autumn in northern Italy, visiting the Valle d'Aosta, the Tyrol, Verona and Venice (where he showed his sketches to both the Callcotts and had long discussions with Augustus). Lewis spent an even longer period in central and southern Italy in 1838–40. He resided in Florence and Rome and spent the latter months of 1838 in and around Naples, making two unsuccessful attempts to explore further afield: in Calabria the inhabitants were hostile and he nearly starved, and when he sailed for Palermo he was cast ashore at Mola di Gaeta. He spent several evenings with the Palmers in Corpo di Cava, near Naples, and in Rome, recounting his southern adventures, displaying his sketches and studies, and advising them on sketching viewpoints. Illness on this visit prevented him from producing as much work as anticipated and in 1840 he left Rome for his more famous travels to Constantinople and Egypt.

JOHN MARTIN (1789–1854)
See cat. 14

Martin was born near Haydon Bridge, just south of England's most awesome and conspicuous Roman ruins, Hadrian's Wall, and moved to London in 1806. He specialized in dramatic scenes of disaster and destruction, inspired by famous episodes from the Bible, literature and classical antiquity. Their common characteristics were violent skies with raging storms or apocalyptic light effects, swarming crowds of minute agitated figures, and landscapes or cityscapes of immense scale and complexity. His paintings were often of vast size, while his prints after them were frequently mezzotints, the dense velvety blackness of which reinforced their sensational subject-matter. Martin was neither a traveller nor a topographer and he never visited Italy. His spectacular reconstructions of events are largely imaginary, but he is known to have consulted sources both ancient and modern to add verisimilitude to his visionary scenes.

THE REVD THOMAS MILLS (1791–1879)
ANNE MILLS (ca. 1795–1827)
See cat. 67

Thomas Mills was the third and youngest son of Thomas Mills (1749–1834) of Saxham Hall, Suffolk, who gave the copy of Raphael's *Transfiguration* to Dulwich College in 1796 (see fig. 33 on p. 100). He was a student at Christ Church, Oxford, was appointed one of the chaplains to the royal family in 1816, and later held the livings of several Suffolk and Essex parishes including that of his father's village, Great Saxham. In 1815 he married Anne, daughter of Nathaniel Barnardiston, and between May and August 1820 the couple made a fifteen-week tour of the Continent, the subject of a journal illustrated with drawings and watercolours. The latter must certainly be the work of Anne who was well known in Suffolk for her beautiful drawings. They travelled out through France, stopping at Paris, Versailles and Fontainebleau where (amongst other sights) they enjoyed seeing the small mahogany table at which Napoleon had signed his abdication in 1814. After crossing the Alps by the Mont Cenis Pass, they arrived in Turin on 14 June and travelled across to Mantua, Padua and Venice where they spent five days (25–30 June). Returning westwards they stopped at Vicenza, Verona, Desenzano, Bergamo, Como and Lake Maggiore before returning over the Simplon Pass (20 July) and spending nearly a month in Switzerland before returning down the Rhine. Throughout this time they saw and heard constant reminders of the recent war in Europe; soon after they reached Italy they were shown the site of the battle of Marengo and at the very end of their tour they visited the field of Waterloo.

SAMUEL PALMER (1805–1881)
See cats. 11, 36, 38, 49, 71; fig. 3
HANNAH PALMER (1818–1893)
See cat. 12

Samuel Palmer was born in Newington, near the Old Kent Road, and his first experience of the countryside was in the fields around Dulwich. From an early age he was intensely conscious of the natural world, creating remarkable drawings of visionary mood when he was barely out of his teens and living in Shoreham in Kent.

On 30 September 1837 he married Hannah, then aged nineteen, the eldest child of the painter John Linnell. At Linnell's insistence, it was a civil ceremony, despite the strong faith and church-going habits of the couple themselves. Palmer had long wished to visit Italy and now, like Augustus Wall Callcott and Maria Graham in the 1820s, the Palmers spent their honeymoon there. However, unlike the Callcotts, they were as much concerned with the life and landscape of the present as with the art of the past, they were more conservative in their tastes and they also spent far longer in Italy. They left England in early October 1837 and travelled through France and over the Simplon Pass, reaching Rome in mid November after brief visits to Milan and Florence. In Rome most of Hannah's time, both now and later, was occupied in copying work for her father. This huge and gruelling task, which damaged both her health and her eyesight, was eventually managed only with help from her husband and from Linnell's pupil Albin Martin. In an attempt to escape the heat of summer, the Palmers paid substantial visits to Naples and Tivoli and their environs (between June and December 1838) and also to Subiaco and Civitella (June and July 1839). They spent part of August 1839 at Papigno in Umbria, moving on to Florence by mid September for a visit of some seven weeks before returning home as they had come, through Milan and Paris.

The Linnells were not over-enthusiastic about the Palmers' marriage; Hannah had eight younger siblings,

ending in twins born in 1835, and would be sorely missed at home. The Italian honeymoon, also regarded with disfavour by the Linnells, was made possible by a loan of £300 from Samuel's friend the painter George Richmond (1809–1896) who, with his wife Julia and small son Tommy, accompanied them to Italy and spent time there with them. Palmer repaid this loan at the end of July 1840. They were also helped by letters of introduction such as Callcott's to Penry Williams and by Maria Callcott's list of things to study in Florence. Hannah's work for her father consisted chiefly of colouring sets of engravings of the frescos of Raphael in the Loggia in the Vatican and of Michelangelo in the Sistine Chapel. In the latter case the prints were recently published mezzotints by Linnell himself after drawings which he believed to be the work of Michelangelo. These drawings, which had once belonged to Reynolds, were by now in the collection of Samuel Rogers. In 1841 Linnell took Samuel and Hannah to see the drawings and in 1856, after the poet's death, he bought them for himself.

HENRY PARKE (ca. 1792–1835)
See fig. 9
Parke was both a pupil of John Soane and one of his architectural draughtsmen. He made many of the finest drawings which Soane used to illustrate his lectures as Professor of Architecture at the Royal Academy. Parke's travels between 1820 and 1824 included visits to Italy, Sicily and Greece; together with others in Soane's circle he made measured drawings of the ancient buildings of Rome and Pompeii and also some of more recent structures.

JOHN PARTRIDGE (1790–1872)
See fig. 15
A portrait painter from Glasgow, Partridge travelled to France around 1823 and thence to Italy, returning to England in 1827. He was soon extremely fashionable,

painting Queen Victoria and Prince Albert in 1840 and becoming 'Portrait-painter Extraordinary to Her Majesty' two years later.

SAMUEL PROUT (1783–1852)
See cats. 9, 10, 21, 22, 51, 56, 66; fig.10
Prout was born in Plymouth but settled in London by 1808. Thereafter, when not engaged on his European sketching tours, he was firmly based in South London, living in Stockwell and Camberwell. He is recorded as teaching at Dr Glennie's School in Dulwich Grove in 1809 and was still doing so in 1821. In 1836 illness forced him to move to Hastings for a time, but he ended his days in South London, living at 5 De Crespigny Terrace, Denmark Hill, from 1844 to 1852 and he was buried in West Norwood Cemetery.

Prout's first visit to Italy (including his only recorded visit to Rome) took place in 1824 and he began exhibiting watercolours of Italy the following year. Of the five Italian scenes he exhibited in 1825, three were depictions of Venice, making him the first-comer to this lucrative field among early nineteenth-century British artists. He obtained the very high price of 50 guineas for one of them, a view of the Rialto bridge, and it was thanks to Prout's encouragement that Bonington concentrated his attentions on Venice the following spring.

Prout may well have visited Venice again in the later 1820s. Year after year, right up to 1850, he painted and exhibited new versions of many of his Italian scenes. These were not replicas, which would have been tediously time-consuming, but variants of diverse size with fresh foreground incidents and capricious modifications of architecture. Apart from his depictions of Italy in the *Landscape Annuals* for 1830 and 1831, he provided Italian illustrations in a variety of books. These included the scenes engraved in William Brockedon's *Road Book, from London to Naples* (1835) and lithographs in his own *Sketches in France, Switzerland and Italy* (1839).

JOHN RUSKIN (1819–1900)

See cat. 8; figs. 13, 29

Ruskin, the son of a sherry-merchant, spent much of his life in South London, living on Herne Hill and Denmark Hill from 1823 to 1871. When his parents took him to northern Italy on their Continental tours of 1833 and 1835, the boy was already conversant with Italian scenes through the drawings and prints of Prout. These scenes were, in fact, the chief stimulus behind the tours. Ruskin had also already fallen under the spell of the engraved work of Turner, most famously the vignettes in Rogers's *Italy*, a copy of which he received on his thirteenth birthday in 1832. Italy and Turner, both together and separately, were the two principal influences and passions which were to dominate his life. Ruskin's anger in 1836 at criticism of a Turner painting – with Shakespeare's Juliet transposed from Verona to Venice – led to his first direct contact with the painter whose works he was later to defend, expound and collect. He initially studied both Italy itself and Italian painters in relation to Turner's art, and Venice inspired some of his most eloquent art criticism.

Of Ruskin's many tours and visits to Italy, two are of particular relevance to the present study. The first took place in 1840–41 when he spent nine months travelling after he had abandoned his studies in Oxford following a breakdown. In an age when exhaustion and the coughing of blood were frequently portents of an early death, Ruskin's parents were taking no risks with their adored only child; on doctor's orders, they all set off for the south in late September. They travelled through France, reaching Rome two months later via Lucca, Pisa, Florence and Siena. After some six weeks in Rome they left it in early January to spend nearly three months further south, mostly in Naples and its environs. In late March they returned to Rome for a further short visit before returning north via Perugia, nearly a week in Florence and ten days in Venice, then Milan, Turin and the Mont Cenis Pass.

In 1845 Ruskin made his first tour abroad without his parents (but accompanied by a manservant and a mountain guide from Chamonix); however, he wrote to his father (at his office in the City) virtually every day from 2 April to 5 November and very occasionally a separate letter to his mother at home. He slowly retraced their earlier route from Genoa to Florence, stopping for a week in Lucca and over two weeks in Pisa. After nearly six weeks in Florence he headed north in early July and spent the next two months in several different places in the lakes and mountains, including Macugnaga under Monte Rosa, Baveno (where J.D. Harding joined him, remaining his companion for a month) and Desenzano. After a short stay in Verona Ruskin spent five weeks in Venice before returning home using the Simplon Pass. His championship of Turner in *Modern Painters* I (1843) led him to a close study of other artists for the ensuing volumes, particularly the central Italian painters of the Early Renaissance and those of the Venetian High Renaissance, subjects which he continued to pursue on his later tours of Italy.

JOSEPH SEVERN (1793–1879)

See cat. 7

Severn was apprenticed by his father to an engraver but he disliked the interminable rigours of copying and became a student at the Royal Academy Schools where he won a medal for an historical painting in 1818. In the autumn of 1820 he accompanied his sick friend John Keats to Italy and after the poet's death there from consumption in February 1821 he obtained a three-year travelling pension from the Royal Academy which enabled him to remain in Rome. Here he became very successful, painting landscapes and genre scenes for residents and tourists, and (apart from occasional visits) did not return to London until 1841. During these twenty years he performed innumerable acts of kindness to British visitors to Rome: advising here, effecting an introduction there, even replenishing a young artist's

colours with supplies fresh from England. As Ruskin later wrote in *Praeterita*, "He understood everybody, native and foreign, in what was nicest in them, and never saw anything else than the nicest Lightly sagacious, lovingly humorous, daintily sentimental, he was in council with the cardinals to-day, and at picnic in Campagna with the brightest English belles to-morrow; and caught the hearts of all in the golden net of his good will and good understanding."[3] On his return to London he submitted a design for a fresco in the new Houses of Parliament, but without success. Thanks to his many Italian contacts, in 1861 he became British Consul in Rome, a post which he held until 1872 by which time Rome had become the official capital of the newly united Italy. He died in Rome and is buried next to Keats in the Protestant Cemetery.

CLARKSON STANFIELD (1793–1867)
See cats. 23, 57

Stanfield explored the Italian Alps in 1824 with William Brockedon when the latter was trying to establish the route of Hannibal and his army on their famous crossing of 218 BC and he later contributed drawings to Brockedon's *Road Book, from London to Naples* (1835) and his *Italy, Historical, Classical and Picturesque* (1842–43). Stanfield's visit to northern Italy in 1830 led to his drawings in *Heath's Picturesque Annual* for 1832, while his final visit to Italy, via France and Switzerland, provided material for many paintings over the rest of his life. This tour, which lasted from August 1838 to March 1839, was undertaken with his friend Thomas George Fonnereau (1789–1850) who had recently benefited from a legacy and abandoned his work as a lawyer for a life devoted to literature and the arts. After their return Fonnereau published a few copies of *Memorials of a Tour in Italy, from Sketches by T.G.F., inspired by his Friend and Fellow-traveller, C.S., Esq., R.A.* Stanfield's Italian subjects are most frequently marine or mountainous (e.g. Ischia and the north Italian lakes), reflecting his two very diverse careers before he took up easel painting: ten years in the merchant service and Royal Navy (1808–18) and another ten as a painter of theatrical scenery. His huge panoramas painted for the pantomimes at Drury Lane included an outstanding one of Venice created in 1831. Some of his small and vivid sketches of the eruption of Vesuvius on New Year's Day 1839, and his visit up the mountain immediately afterwards, were once misattributed to Turner.

THOMAS STOTHARD (1755–1834)
See cat. 68

Stothard specialized in painting literary figure subjects and contributed illustrations for engraving in an enormous number of works, those for Samuel Rogers being among his last. In September 1815 he travelled with the sculptor Chantrey to Paris where he studied the paintings Napoleon had seized from all over Europe; these were now being taken down in the Musée Napoléon and about to be returned to their rightful owners. Among the famous works looted from Italy, including ones by Titian and Correggio, he decided that Raphael's *Transfiguration* surpassed everything else and he made notes and a record of some of its colouring. Later he drew ten graceful watercolours of maidens in a Florentine garden for the English edition of Boccaccio's *Decameron* published in 1825; a similar work in *The Keepsake for 1829* was accompanied by Coleridge's poem 'The Garden of Boccaccio'. In 1827, after a week of scrutinizing paintings in Florence, Maria Callcott declared that, in the garden scenery of his altarpieces, "Botticelli is so like Stothard that one might fancy the old Tuscan's spirit had taken its abode in our veteran."[4]

JOSEPH MALLORD WILLIAM TURNER (1775–1851)

See cats. 13, 16, 27, 32–35, 37, 39, 46–48, 50, 54–55, 58–62, 64; figs. 4, 8, 14

Turner was the son of a Covent Garden barber and showed his exceptional powers early in life; he had a watercolour accepted at the Royal Academy exhibition when just fifteen and was elected a full member of the Academy when still only twenty-six. He spent his entire life in London, but left it nearly every summer on a sketching tour in order to garner fresh material. Italy was the most important single influence on his work, nourishing his imagination, revolutionizing his colour and vision, and furnishing him with multifarious themes and topographical subjects throughout his career.

He made his first and longest tour of Italy in 1819 when he was absent from London for six months (31 July to 1 February 1820). During this period he filled over twenty sketchbooks with on-the-spot studies, mostly in pencil in small books and occasionally in watercolour in a few larger ones. These were not confined to landscape sketches; he also recorded buildings, sculpture, paintings and everyday life. He crossed the Alps over the Mont Cenis Pass and then visited Turin, Milan and the lakes. He stopped in Venice for just a few days around 10 September. He spent most of his time in Rome, with a visit to the south in November and a quick look at Florence around Christmas on his way home. On his second visit, in 1828, he travelled through Genoa, Pisa and Florence and did not visit Venice. He remained in Rome for nearly three months and concentrated on painting in a studio alongside Eastlake, exhibiting three oil paintings shortly before he left. He returned to Venice for a week in September during his tour of 1833 (funded by his friend and patron H.A.J. Munro, who desired a watercolour of that city) and for a fortnight on that of 1840 (20 August to 3 September). He experienced some of northern Italy's mountains, lakes and valleys in the course of both his earliest Alpine explorations (1802) and much later ones (1836, 1842, 1843). Although Turner often copied and profited by the Italian experiments of associates such as Eastlake, Bonington and Stanfield, his own views and visions of Italy are among the most beautiful and penetrating ever painted.

THOMAS UWINS (1782–1857)

See cats. 30–31; figs. 18, 32

Thomas Uwins spent over six years in Italy. He arrived in northern Italy in October 1824, having travelled overland via Paris and Geneva, and in March 1831 he caught the steamboat from Livorno to Marseilles and returned through France. During these years he often contemplated returning to London, in 1828 writing that, "Dulwich I should like on account of the neighbourhood of good pictures of the very class which I shall aim at; but I fear the air of Dulwich will be too damp for me."[5] However, a new commission from a patron in Italy always put an end to such plans and the return was constantly postponed.

Uwins lived principally in Naples, claiming to be the first English painter to have practised there. As a long-term resident he welcomed many British painters on their visits to the south including Wilkie in 1826 and both Callcott and William Havell in 1828. He produced a steady stream of paintings of Italian life for over thirty years and his career after his return to England was attended with success. He was elected an Associate of the Royal Academy in 1833 and a full Royal Academician in 1838, receiving the first diploma signed by Queen Victoria. In 1844 he became Librarian to the Royal Academy; in 1845 Surveyor of Pictures to the Queen, after the death of Callcott; and in 1847 he succeeded Eastlake as Keeper of the National Gallery.

JOHN VARLEY (1778–1842)

See cat. 2

A prolific watercolourist and busy teacher with a large family and small income, Varley did not travel to Italy.

Nevertheless he was strongly committed to the structured classical compositions found in the work of Claude and Wilson, so that many of his British scenes had a notably Italianate air.

HENRY WARREN (1794–1879)
See cat. 65

Warren worked chiefly in watercolour, depicting a variety of subjects but becoming famous for depictions of Arabia which he never visited. Many of his scenes were engraved as book illustrations in topographical works and in the 'annuals' and in his latter years he published several textbooks and manuals on drawing.

HUGH WILLIAM WILLIAMS (1773–1829)
See cat. 17

Although Welsh by birth, Williams was educated in Scotland: he was a pupil of David Allan (1744–1796) who had spent many successful years in Italy in 1764–77, painting grand historical subjects and the informal conversation pieces for which he is best known today. Williams explored Italy in 1816–17 as part of a larger tour of the Mediterranean, described on his return to Scotland in the two volumes of his *Travels in Italy, Greece, and the Ionian Isles* (1820). According to the letters that form this account, he devoted much time to studying the art collections of Milan, Parma, Modena, Bologna and Florence on his way to Rome. His journey also included an unusual detour: to the island of Elba, where Napoleon had been confined in 1814–15. After many letters on Rome, two very brief ones describe Williams's stay in the south of Italy which he had reached by January 1817. He visited Naples, Pompeii and Paestum and then left in the middle of February, catching a boat from Naples to Otranto (on the very heel of Italy) on his way to Greece. His love of Claude and Poussin is evident in many of his paintings of classical landscapes and his views of Greece earned him the nickname of 'Grecian' Williams.

PENRY WILLIAMS (*ca.* 1800–1885)
See cats. 5, 20, 40, 41, 53

Penry Williams was born in Merthyr Tydfil in South Wales. After a short period in London as a student at the Royal Academy Schools, supported by the patronage of two Welsh iron magnates, he went to Rome in 1826–27 with the financial backing of a third. Before long he was successful enough to dissolve that contract and he spent virtually the whole of his life in Italy, dying in Rome in his mid eighties. His first intention was to specialize in landscape, but he soon came under the influence of Eastlake and turned to scenes from Roman and Italian everyday life. After Eastlake's return to London in 1830, Williams took over his rooms in Piazza Mignanelli and became an important figure among the Britons in Rome, welcoming newcomers like Lear and the Palmers, assisting them and accompanying them on sketching tours. As Hannah Palmer reassuringly told her parents, Williams was at the centre of "a circle of English Artists who are all friendly nice people [and] all meet at dusk and dine together. We join them and enjoy very much the cheerful and improving conversation which generally occurs." Williams also became noted as an expert in Italian dialects and his studio was a popular tourist sight. In 1846 he contributed three costume illustrations to the second volume of Lear's *Illustrated Excursions in Italy*. His work was so much in demand from visitors to Rome that he had to repeat successful themes and compositions many times and he achieved an international reputation far greater than most of his British contemporaries.

NOTES
1 W. Thornbury, *The Life of J.M.W. Turner, R.A.*, 2nd edn, London 1877, p. 71.
2 J. Gage (ed.), *Collected Correspondence of J.W.W. Turner*, Oxford 1980, p. 103.
3 John Ruskin, *Praeterita*, ed. K. Clark, London 1949, p. 252.
4 Lloyd and Brown (edd.) 1981, entry for 14 December 1827.
5 Uwins 1858, II, p. 98.

List of Exhibits

1 THOMAS GIRTIN, *The Grand Canal, Venice, looking east from Palazzo Flangini to San Marcuola* (after Canaletto), 1797, The British Museum

2 JOHN VARLEY *Suburbs of an ancient city*, 1808, Tate Gallery, London

3 WILLIAM COWEN, *St Peter's and the Castle and Bridge of Sant'Angelo*, 1823, The Duke of Devonshire and Chatsworth Settlement Trustees

4 J.F. LEWIS, *Florence: the Palazzo Vecchio and the Uffizi*, 1838, The Visitors of the Ashmolean Museum, Oxford

5 PENRY WILLIAMS, *The feast in the House of Levi* (after Veronese), *ca.* 1827,
The National Museums and Galleries of Wales, Cardiff

6 WILLIAM ETTY, *Female nude posing beside a copy of the Medici Venus at the Royal Academy Life Class, ca.* 1835, Courtauld Gallery, London (Witt Collection)

7 JOSEPH SEVERN, *The Upper Church of San Francesco, Assisi, ca.* 1820–30, Victoria Art Gallery, Bath and North East Somerset Council

8 JOHN RUSKIN, *The Capitol from the Forum*, 1841, The Visitors of the Ashmolean Museum, Oxford

9 SAMUEL PROUT, *The Column of Phocas, ca.* 1830–40, The Duke of Devonshire and Chatsworth Settlement Trustees

10 SAMUEL PROUT, *The Temples of Saturn and of Vespasian, Rome, ca.* 1830–40,
The Duke of Devonshire and Chatsworth Settlement Trustees

11 SAMUEL PALMER, *The Street of the Tombs, Pompeii*, 1838, Private collection

12 HANNAH PALMER, *Pompeii with Vesuvius behind it*, 1838, Private collection

13 J.M.W. TURNER, *The Claudian Aqueduct and Temple of Minerva Medica*, 1819, Tate Gallery, London

14 JOHN MARTIN, *The destruction of Pompeii and Herculaneum*, 1826, University of Manchester (Tabley House Collection)

15 EDWARD LEAR, *Porta Maggiore, Rome*, 1838, Tate Gallery, London

16 J.M.W.TURNER, *The Colosseum by moonlight*, 1819, Tate Gallery, London

17 H.W. WILLIAMS, *Pompeii*, 1817, The Syndics of the Fitzwilliam Museum, Cambridge

18 JOSEPH MICHAEL GANDY, *Classical composition: interior of a ruined palace*, Victoria and Albert Museum, London

19 CHARLES TURNER after C.L. EASTLAKE, *Italian goatherds*, 1825, The British Museum

20 PENRY WILLIAMS, *The procession to the christening, a scene at L'Ariccia near Rome*, 1832, Cyfarthfa Castle Museum and Art Gallery

21 SAMUEL PROUT, *The fish market, Rome*, 1831, The Duke of Devonshire and Chatsworth Settlement Trustees

22 SAMUEL PROUT, *The Forum of Nerva, Rome, ca.* 1825–30, Victoria and Albert Museum, London

23 CLARKSON STANFIELD, *The Dogana and the Church of the Salute, Venice, ca.* 1830–31, The British Museum

24 EDWARD SMITH after C.L. EASTLAKE, *An Italian family, prisoners with banditti*, 1840, The British Museum

25 IMITATOR OF SAMUEL PROUT, *The interior of the Colosseum, ca.* 1830, Victoria and Albert Museum, London

26 WILLIAM COLLINS, *Poor travellers at the door of a Capuchin convent near Vico, Bay of Naples*, 1839, The Board of Trustees of the National Museums and Galleries on Merseyside (Emma Holt Bequest, Sudley House)

27 J.M.W. TURNER, *The entrance to the via della Sagrestia, Rome*, 1819, Tate Gallery, London

28 J.F. LEWIS, *Easter Day at Rome – pilgrims and peasants of the Neapolitan states awaiting the benediction of the pope at St Peter's*, 1840, Northampton Museums and Art Gallery

29 JOHN SCARLETT DAVIS, *The interior of St Peter's, Rome*, 1842–44, The National Museums and Galleries of Wales, Cardiff

30 S. SANGSTER after THOMAS UWINS, *The festa of Piè di Grotta*, 1838, Victoria and Albert Museum, London

31 THOMAS UWINS, *The saint manufactory*, 1832, Leicester City Museums

32 J.M.W. TURNER, *Modern Italy – the pifferari*, 1838, Glasgow Museums: Art Gallery and Museum, Kelvingrove

33 J.M.W. TURNER, *Landscape: composition of Tivoli*, 1817, Private collection

34 J.M.W. TURNER, *Tivoli: Tobias and the angel*, 1830s, Tate Gallery, London

35 J.M.W. TURNER, *Italian bay*, 1828, Tate Gallery, London

36 SAMUEL PALMER, *Rome and the Vatican from the western hills – pilgrims resting on the last stage of their journey, ca.* 1838–45, The Syndics of the Fitzwilliam Museum, Cambridge

37 J.M.W. TURNER, *Marengo, ca.* 1827, Tate Gallery, London

38 SAMUEL PALMER, *The Bay of Naples*, 1838, Agnew's, London

39 J.M.W. TURNER, *Vesuvius*, 1819, Tate Gallery, London

40 PENRY WILLIAMS, *Civitella Gazette*, 1839, The British Museum

41 PENRY WILLIAMS, *Olevano Romano and the Serpentara*, 1839, The British Museum

42 R.P. BONINGTON, *Entrance to the Grand Canal, with Santa Maria della Salute*, 1826, The Visitors of the Ashmolean Museum, Oxford

43 EDWARD LEAR, *Paliano*, 1838, Victoria and Albert Museum, London

44 R.P. BONINGTON, *The Castelbarco Tomb, Verona*, 1827, City of Nottingham Museums: Castle Museum and Art Gallery

45 EDWARD LEAR, *Church of Santi Quattro Coronati, Rome*, 1838, Tate Gallery, London

46 J.M.W. TURNER, *San Giorgio Maggiore, Venice: morning*, 1819, Tate Gallery, London

47 J.M.W. TURNER, *A villa (Villa Madama – moonlight)*, ca. 1827, Tate Gallery, London

48 J.M.W. TURNER, *The Castel dell'Ovo and Bay of Naples*, 1819, Tate Gallery, London

49 SAMUEL PALMER, *Villa d'Este, Tivoli*, ca. 1838–39, The Visitors of the Ashmolean Museum, Oxford

50 J.M.W. TURNER, *Childe Harold's Pilgrimage – Italy*, 1832, Tate Gallery, London

51 SAMUEL PROUT, *Venice, the Palazzo Contarini-Fasan on the Grand Canal*, 1840?, Victoria and Albert Museum, London

52 EDWARD LEAR, *Amalfi*, 1838, Victoria and Albert Museum, London

53 PENRY WILLIAMS, *Pozzuoli*, 1831, The National Museums and Galleries of Wales, Cardiff

54 J. MIDDIMAN AND JOHN PYE after J.M.W. TURNER, *La Riccia*, in James Hakewill, *A Picturesque Tour of Italy* (1818–20), Cecilia Powell

55 EDWARD GOODALL after J.M.W. TURNER, *Florence*, in *The Keepsake for 1828*, Cecilia Powell

56 CHARLES HEATH after SAMUEL PROUT, *Petrarch's House at Arquà*, in *The Landscape Annual for 1830*, Jan Piggott

57 ROBERT WALLIS after CLARKSON STANFIELD, *Murano*, in *Heath's Picturesque Annual for 1832*, Jan Piggott

58 ROBERT WALLIS after J.M.W. TURNER, *Lake Albano*, in *The Keepsake for 1829*, Jan Piggott

59 EDWARD GOODALL after J.M.W. TURNER, *Marengo*, in Samuel Rogers, *Italy* (1842 edn), Jan Piggott

60 EDWARD GOODALL after J.M.W. TURNER, *Florence*, in Samuel Rogers, *Italy* (1830), Private collection

61 JOHN PYE after J.M.W. TURNER, *Paestum*, in Samuel Rogers, *Italy* (1830), Private collection

62 WILLIAM MILLER after J.M.W. TURNER, *Venice (The Rialto – moonlight)*, in Samuel Rogers, *Poems* (1834), Cecilia Powell

63 J. THOMPSON after A.W. CALLCOTT, *Grotto of Posillipo* and after EDWIN LANDSEER, *The Cardinal*, in Samuel Rogers, *Italy* (1839 edn), Jan Piggott

64 EDWARD FINDEN after J.M.W. TURNER, *Santa Maria della Spina, Pisa*, in *The Life and Works of Lord Byron* (1833–34), vol. 5, Cecilia Powell

65 EDWARD FINDEN after HENRY WARREN, *Rome. Interior of the Coliseum*, in Lord Byron, *Childe Harold's Pilgrimage* (1845 edn), Jan Piggott

66 ROBERT WALLIS after SAMUEL PROUT, *Mocenigo Palace, Venice, the residence of Lord Byron*, in *The Landscape Annual for 1831*, Jan Piggott

67 ANNE MILLS, *Contadine near Bozzolo*, in Thomas Mills, 'Journal of a Tour made in 1820', after 1826, Private collection

68 JOHN HENRY ROBINSON after THOMAS STOTHARD, *The funeral*, in Samuel Rogers, *Italy* (1830), Jan Piggott

69 J. CLARK after C.L. EASTLAKE, *Peasants in search of banditti*, in Maria Graham, *Three Months passed in the Mountains East of Rome, during the Year 1819* (1820), Cecilia Powell

70 J. CLARK after C.L. EASTLAKE, *Station of the brigands near Guadagnola*, in Maria Graham, *Three Months passed in the Mountains East of Rome, during the Year 1819* (1821 edn), Cecilia Powell

71 SAMUEL PALMER, *The vintage*, in Charles Dickens, *Pictures from Italy* (1846), Cecilia Powell

72 EDWARD LEAR, *Civitella di Subiaco*, in Edward Lear, *Views in Rome and its Environs* (1841), Private collection (not illustrated)

Select Bibliography and Further Reading

David Blayney Brown (1992), *Turner and Byron*, exhib. cat., London, Tate Gallery

Jeanne Clegg and Paul Tucker (1993), *Ruskin and Tuscany*, exhib. cat., London, Sheffield and Lucca

W. Wilkie Collins (1848), *Memoirs of the Life of William Collins, Esq, R.A.*, 2 vols., London

Charles Dickens (1846), *Pictures from Italy*, London

Joan Evans and John Howard Whitehouse (edd.) (1956), *The Diaries of John Ruskin, 1835–1847*, Oxford

Alexander Gilchrist (1855), *Life of William Etty, R.A.*, 2 vols., London

J.R. Hale (1954), *England and the Italian Renaissance*, London (new edn 1996)

J.R. Hale (ed.) (1956), *The Italian Journal of Samuel Rogers*, London

Francis Haskell and Nicholas Penny (1981), *Taste and the Antique. The Lure of Classical Sculpture 1500–1900*, New Haven and London

William Hazlitt (1826), *Notes of a Journey through France and Italy*, included in P. P. Howe (ed.), *The Complete Works of William Hazlitt*, London, 1932, vol. 10

Raymond Lister (ed.) (1974), *The Letters of Samuel Palmer*, 2 vols., Oxford

Michael Liversidge and Catharine Edwards (edd.) (1996), *Imagining Rome. British Artists and Rome in the Nineteenth Century*, exhib. cat., Bristol City Museum and Art Gallery

Christopher Lloyd and David Blayney Brown (edd.) (1981), *The Journal of Maria, Lady Callcott, 1827–28* (microfiche edition), Oxford

Richard Lockett (1985), *Samuel Prout 1783–1852*, exhib cat., London, Victoria and Albert Museum

Edward Malins (1968), *Samuel Palmer's Italian Honeymoon*, London

Peter Murray (1980), *Dulwich Picture Gallery. A Catalogue*, London

Vivien Noakes (ed.) (1988), *Edward Lear. Selected Letters*, Oxford

Patrick Noon (1991), *Richard Parkes Bonington. 'On the Pleasure of Painting'*, exhib. cat., New Haven, Yale Center for British Art

Jan Piggott (1993), *Turner's Vignettes*, exhib. cat., London, Tate Gallery

Cecilia Powell (1987), *Turner in the South. Rome, Naples, Florence*, New Haven and London

Ronald T. Ridley (1992), *The Eagle and the Spade. Archaeology in Rome during the Napoleonic Era*, Cambridge

David Robertson (1978), *Sir Charles Eastlake and the Victorian Art World*, Princeton

Harold I. Shapiro (ed.) (1972), *Ruskin in Italy. Letters to his Parents 1845*, Oxford

Lindsay Stainton (1985), *Turner's Venice*, London

Mrs Uwins (1858), *A Memoir of Thomas Uwins, R.A.*, 2 vols., London

Timothy Wilcox (1990) (ed.), *Visions of Venice. Watercolours and Drawings from Turner to Procktor*, exhib. cat., London, Bankside Gallery

Index

Ackermann, Rudolph 92, 94
Acton, Sir Richard 54
Albert, Prince 18
Allan, David 115
Allnutt, John 60
Allston, Washington 74, 105
Arundel, Lord 54

Baring, Sir Thomas 40
Barry, Sir Charles 18, 106
Basevi, George 24
Berchem, Nicolaes 87
Bewick, William 15
Bicknell, Elhanan 40
Blake, William 65, 106
Boccaccio 14, 113
Bonington, R.P. 71, 76, 80, 104
Botticelli, Sandro 113
Brockedon, William 106, 111, 113
Browning, Robert 16–17
Bulwer Lytton, Edward 34
Byron, Lord 19, 30, 33, 72, 82–87, 94, 96, 97–99

Callcott, Sir A.W. 18, 48, 69, 73, 97, 105, 109, 111, 114
Callcott, Maria *see* Graham
Callow, William 72–73
Canaletto 10
Canova, Antonio 12
Chantrey, Francis 12, 113
Cheney, Edward 106
Claude Lorrain 16, 18, 22, 23, 47, 57–67, 74
Coleridge, S.T. 35, 113
Collins, Wilkie 35, 105
Collins, William 48–50, 71, 72, 74, 75–76, 82, 105
Constable, John 59, 60
Cowen, William 12–13, 106
Cozens, J.R. 10, 107
Cromek, T.H. 27–28, 106
Cuyp, Aelbert 16, 58–59

Dante 14, 107
David, J.-L. 69
Davis, John Scarlett 50–52, 106
Devonshire, 6th Duke of 13, 106
Devonshire, Elizabeth, Duchess of 24
Dickens, Charles 33, 36–37, 94, 100–03
Disney, General Sir Moore 40
Donaldson, T.L. 34
Dughet, Gaspard 58–59, 65

Eastlake, Sir Charles 18, 24, 39, 40, 45–48, 50, 76–78, 99–101, 105, 106–07, 108, 114, 115
Etty, William 16, 107
Evans, Richard 107

Fonnereau, T.G. 113

Gandy, J.M. 35, 107
Gell, Sir William 34, 107
Gibbon, Edward 29
Gibson, John 12, 25
Giotto 17, 108
Girtin, Thomas 10, 107–08
Glover, John 60
Graham, Maria 46–48, 58, 71, 100–101, 105, 108, 111, 113
Guest, Josiah John 41

Hakewill, James 91, 94
Harding, J.D. 72, 94, 97, 104, 112
Havell, William 114
Hazlitt, William 42, 43, 50, 58, 102
Hinxman, John 40, 106
Hoare, Sir Richard Colt 14

Ingres, J.-A.-D. 19

Jameson, Anna 17, 25–26
Jones, Thomas 75–76

Keats, John 17, 72, 108, 112, 113
Knight, Charles 109

Lasinio, Carlo 102, 105
Lawrence, Sir Thomas 12, 15
Leaf, William 40
Lear, Edward 19, 32–33, 41, 42–44, 59, 71, 72, 74, 78, 80, 84, 85, 91, 100, 108–09, 115
Leonardo da Vinci 15
Lewis, J.F. 14–15, 19, 39, 50–51, 104, 109
Linnell, John 19, 66, 71, 105, 110–11
Lockhart, J.G. 34

Martin, Albin 71, 74, 110
Martin, John 31, 34, 109
Michelangelo 11, 15, 111
Mills, Thomas and Anne 44, 92, 98–100, 110
Milton, John 15
Monro, Dr Thomas 63, 107–08
Moore, Thomas 17, 19, 21
Munro, H.A.J. 114
Murray, John 17, 94, 97

Napoleon 9, 10–11, 30, 69, 96
Nazarene Brotherhood 18, 105, 108

Palgrave, Francis 17
Palmer, Hannah 29, 34, 36, 42, 43, 44, 54, 71, 74, 94, 105, 109, 110–111, 115
Palmer, Samuel 13–14, 19, 26, 28–29, 34, 39, 54, 58, 64–67, 71, 72, 73–74, 80, 83, 84, 94, 102–103, 105, 109, 110–11
Parke, Henry 25, 111
Partridge, John 47, 111
Petrarch 14, 93, 98

Piranesi, G.-B. 23, 24, 25, 92
Pius VII, Pope 9, 12, 22, 23
Poussin, Nicolas 11, 18, 58–59, 65
Pre-Raphaelite Brotherhood 17–18, 102, 105
Prout, Samuel 25–28, 42, 49, 71, 84, 85, 91, 94, 97, 111

Raphael 11, 14, 15, 51, 99–100, 105, 110, 111, 113
Reynolds, Sir Joshua 15, 111
Richmond, George 111
Rivet, Baron Charles 104
Rogers, Samuel 13, 14, 27, 34, 95–97, 99, 100, 111, 112, 113
Rosa, Salvator 45, 58–59, 74
Rumohr, Carl Friedrich von 18
Ruskin, John 16–17, 22, 36–37, 44, 71, 78–79, 95, 102, 106, 112, 113

Scott, Sir Walter 34–35, 106
Severn, Joseph 17–18, 105, 112–13
Sheepshanks, John 40
Shelley, Mary 47, 95
Shelley, P.B. 81–82
Smith, John 'Warwick' 92
Soane, Sir John 11, 24, 25, 28, 35, 73, 107, 111
Stanfield, Clarkson 43, 84, 97, 102, 104, 113
Starke, Mariana 23
Stothard, Thomas 96–97, 99, 106, 113
Swanevelt, Herman van 26, 58, 107

Thorvaldsen, Bertel 25
Titian 41, 48, 98, 104
Turner, J.M.W. 9, 10, 13–14, 16, 24, 30, 32–33, 34, 46, 50, 53–54, 57–65, 69, 72–73, 77–78, 80–84, 91, 92–97, 102, 105, 108, 112, 114

Uwins, James 109
Uwins, Thomas 19, 39, 51–55, 59, 72, 87–89, 94, 105, 109, 114

Valadier, G. 23, 24
Varley, John 10–11, 114–15
Vasari, Giorgio 17, 99
Vernet, C.-J. 74, 75
Veronese 16, 41, 104
Victoria, Queen 109, 111, 114

Warren, Henry 98, 115
Wilkie, Sir David 48, 105, 114
Williams, H.W. 33–34, 115
Williams, Penry 15, 16, 39, 41, 74, 75, 84, 86, 105, 109, 111, 115
Wilson, Richard 57, 59, 63, 75–76, 81

120